Digital Imaging

for the Underwater
Photographer

Computer

Applications

for Photo

Enhancement

and Presentation

Jack and Sue Drafahl

AMHERST MEDIA, INC. ■ BUFFALO, NY

DEDICATION

This book is dedicated to our daughter, Kristy, the love of our lives. Thanks for your patience and understanding with your photojournalist parents.

Published by:
Amherst Media, Inc.
P.O. Box 586
Buffalo, N.Y. 14226
Fax: 716-874-4508
www.AmherstMedia.com

Publisher: Craig Alesse
Senior Editor/Production Manager: Michelle Perkins
Assistant Editor: Barbara A. Lynch-Johnt

ISBN: 1-58428-061-1
Library of Congress Card Catalog Number: 2001 132049

Printed in Korea.
10 9 8 7 6 5 4 3 2 1

Table of Contents

Introduction

WHEN HISTORY LOOKS BACK at the turn of the 21st century, it will probably be noted as a time when the technology revolution gained real momentum. Product changes no longer took years, but rather months or weeks. It became almost impossible to stay ahead of it all and adapting required new learning skills.

PHOTOGRAPHY WAS A LEADER OF THE PACK WITH ITS EXCITING INNOVATIONS.

Photography was a leader of the pack with its exciting innovations. Digital cameras moved from the novelty position to number one on everyone's Christmas list. Computers, scanners, editing software, inkjet printers, RAM, DVD and Firewire quickly became new interests for the 21st century photographer.

Underwater photography has been less effected by these changes, because it always seems to be a

few steps behind. Eventually, technology developed for land use makes its way underwater, but there is a three to five year time lag. The reason is simple economics. Underwater photographers are a much smaller group, and therefore a less lucrative market for sales

Until the underwater digital camera becomes the norm, most underwater photographers will be using the old silver film process. The progression from film to digital will take years and will cause confusion and controversy along the way. We designed this book to help the underwater photographer make a smooth transition to the digital world.

This high-speed evolutionary change presented us several problems in writing a book on how to interface computers and underwater photography. Divers want to take advantage of this exciting new photographic technology, but could we create a book that wouldn't be out of date before it was even published? The key would be to avoid specific products, as the version numbers change so rapidly. Instead, we would just concentrate our efforts on techniques and digital concepts that apply to underwater pictures. Photography problems that plague divers never seem to vary with time.

PHOTOGRAPHY PROBLEMS THAT PLAGUE DIVERS NEVER SEEM TO VARY WITH TIME.

We made one exception to this game plan. All our illustrations, directions and explanations were based around the image editing software program from Adobe® Systems called Photoshop®. We feel that

this program is the strongest and most enduring photo editing program on the market. Its concepts best state the techniques needed in the digital world and can be applied to any other editing program you decide to purchase.

Eventually, the digital camera will become commonplace underwater. The bulk of the concepts explored in this book

EVENTUALLY, THE DIGITAL CAMERA WILL BECOME COMMONPLACE UNDERWATER.

apply to both the film and digital underwater camera. We are very excited at the varied directions underwater photography is taking and hope you'll benefit from the tips and techniques presented in this book.

The Digital Process

THE STEPS TO THE DIGITAL PROCESS are as easy as one, two, three—input, edit and output. That's all there really is to it. Now that doesn't sound so difficult does it? The technical jargon is what makes it seem complicated.

We know that you're excited to get started into digital, but have plenty of questions. Where do you start? What equipment do you need to buy? Which software program works well with underwater pictures? How much will it cost? Relax and take a deep breath. We know that the choices of hardware and software are mind boggling enough to discourage any new digital photographer. It is our job to

THE TECHNICAL JARGON IS WHAT MAKES IT SEEM COMPLICATED.

help you understand each of these steps so you can set up and use your digital darkroom. Don't worry, because we'll help you get introduced into the digital process—one step at a time.

○ Input

Digital Camera Images

In order to work with your underwater photos on the computer, they must first be converted to a digital file. This conversion of visual data to digital can be done in several ways, but using a digital camera is the easiest. If you have a digital camera to shoot topside pictures on your dive trip, or are lucky enough to have one of the first underwater digital cameras, the task is simple. With these new digital cameras, you simply take a picture and it is immediately converted to a digital file.

TAKE A PICTURE, AND IT IS IMMEDIATELY CONVERTED TO A DIGITAL FILE.

The file is still contained internally in the digital camera, and needs to be transmitted to the computer, so it can be edited and output. This is done in one of two ways. Using the first method, attach your camera to your computer via a communication link that comes with the camera and download the images to the computer. The second method uses a removable image storage device, common to many digital cameras. Simply remove the storage device and insert it into a reader attached to your computer. Once you have your images transferred, you are ready to edit them.

At this point in time, digital cameras are just starting to appear in the underwater world. The prices for the high quality cameras are still steep and few manufacturers have made the commitment to produce underwater housings. There are a few digital video underwater cameras that have the capability of making a digital still image, but most offer very low image resolution. As prices drop and technology soars, it won't be long before underwater digital cameras are the norm rather than a rarity.

Film Images

Currently, the majority of underwater images are still taken on film. Some photographers use slide film and others use color negative film. In order to view these images on the screen, they must be brought into the computer via a scanner and converted to digital data. Your slides, color negatives and even prints can be scanned and saved as a digital image. If digital life was simple, there would be only one type of scanner, but in fact there are three basic types.

THE MAJORITY OF UNDERWATER IMAGES ARE STILL TAKEN ON FILM.

Drum Scanners. The drum scanner is the most expensive and is used mainly by professional labs and offset printing houses. We'll assume you are not interested in buying one of these and concentrate our information on the other two types.

Film Scanners. A film scanner is specifically designed to accept slides and negative film. Film

scanners are presently being made by a variety of camera, film and electronic manufacturers. They all have slightly different features, but they all do about the same job. On some scanners the images remain stationary and a light source moves across the film scanning the data to file. On other models, the light source remains stationary and the film moves. For most film scanners, auxiliary attachments are available that allow them to scan APS film.

The actual scanning takes a relatively short time, so you can scan a multitude of film in a short period of time. Several of the scanners also have an attachment that allows for batch scanning of slides. This is a fabulous time saving device when you have lots of images to input.

When you are looking to purchase a film scanner, the key element is resolution. Many years ago, a conglomerate of photographic companies determined that a 3072 x 2048 pixel image was all that was necessary for a traditional image to be converted to a digital file. That was the beginning

YOU CAN SCAN A MULTITUDE OF FILM IN A SHORT PERIOD OF TIME.

of the Photo CD and it is still the main resolution used today. We find no fault with the billions of dollars spent to determine that answer, so the bottom line is that your film scanner should be able to scan images that are at least at Photo CD resolution. This translates into images that are at least 2048 pixels per inch, or a file size that is at least 18MB (megabytes) when uncompressed.

Flatbed Scanners. The flatbed scanner is designed for capturing prints and flat artwork. It resembles a copy machine since your prints lay on a glass base and the light passes across, scanning the data to a file. In order to determine which flatbed scanner to purchase, you need to decide what the size will be of the photos and artwork that you want to scan into the system. If you decide that 8.5" x 11" is adequate, you can find many inexpensive scanners to choose from. Make sure you find a scanner that has 600–1200 dpi resolution and 36-bit color.

We have seen several new flatbed scanners that also scan film via a special slide and negative holder. These are kind of like Swiss Army knives, offering something for every purpose. They work all right, but in order to achieve the best scanning results, you are better off using a film scanner for all your film transfers. If you need to scan both prints and film, you will probably end up buying one of each kind of scanner to maximize quality. Since scanner prices have dropped drastically, it is now possible, however, to have both types without breaking your pocketbook.

Another consideration when buying a scanner is the way that it communicates with your computer. It could be via a printer port, SCSI, Firewire or USB ports on some of the newer computers. The printer port is the slowest method of all. If a scanner uses a SCSI

port, the board is usually included with the scanner purchase. Check the scanner specifications to determine its communication method. If speed is not an issue, then any method will work.

The physical placement of either scanner should have minimal cord distance, and not interfere with your mouse or keyboard. As with all your computer devices, you should have the scanner on a protected circuit. Keep the scanner covered with a dust cover of some type when it is not in use. Remember that a small particle of dust scanned into your digital file becomes very large and requires extra time to remove using editing software. You should also use a negative brush and compressed air to blow off any dust particles before placing the images in your scanner.

○ Edit

Once your underwater images are digitized to bytes of data, they can be housed on a variety of storage media and then edited using a photo editing program. These programs have become very sophisticated over the years, and can alter the exposure, color balance, contrast, color saturation, gamma, sharpness and a myriad of other tasks that used to be very time consuming in the traditional darkroom. Let's back up a couple of steps and talk about the hardware and software requirements for editing underwater photos.

THESE PROGRAMS HAVE BECOME VERY SOPHISTICATED OVER THE YEARS.

Hardware

Computer. The computer is the hub of your digital darkroom. You may be able to use the one you already have, or you might consider a new one especially designed for working with digital files. We cannot even begin to tell you which computer you should buy, as it will become out-of-date before you can even get it unpacked. Most any computer will work, PC or Mac, but there are a few things to consider when selecting one for editing your underwater images.

The faster the processor speed the better. Few things are more frustrating than waiting for an image to load. We recommend at least 256MB of RAM for serious image editing. That insures that the computer does not use the hard disk as memory, which slows the editing down to $^1/_{10}$ speed. RAM is easy

FEW THINGS ARE MORE FRUSTRATING THAN WAITING FOR AN IMAGE TO LOAD.

to add, so if you find 256 is still not enough, just add in more 128 or 256 RAM chips.

When you first set up your system, you may be tempted to get one large hard drive and use it for both running programs and storing image files. Not a good idea. We recommend at least a two drive system. The primary drive should have all your program files, while the second drive should hold all your image files. The image storage drive will constantly have images being written, rewritten, moved and deleted. You really don't want this to be happening on the same drive as your programs. Believe it or

NETWORKING

If you use more than one computer for editing, we highly recommend that you connect them together using network cards. This system is very inexpensive yet allows you to work on one computer editing images while the other computer is scanning new images. You can easily access images back and forth between computer systems. This really speeds up the process if you have many underwater images to scan and edit.

not, computers *do* make mistakes. It is possible that the computer could accidentally destroy a program file while writing an image file.

If you have room for a third smaller drive, use that one as a scratch drive. A scratch drive is used by your computer to write temporary system files. This process is constantly happening, so it is best separated from both program and image files. That way if any of the drives fail you have not lost everything.

Monitor. Being able to see the image correctly is an important part of the digital process. Most of the e-mail type computers only have a 14"–15" monitor. To edit images comfortably you will need a minimum of a 17" monitor. The larger 19"–21" monitors are more expensive, but sure make editing a breeze. The adapter card that sends the visual data to the monitor should be able to display images at least 1024 x 768 pixel resolution at 24- or 32-bit color. All

LARGER MONITORS ARE MORE EXPENSIVE, BUT SURE MAKE EDITING A BREEZE.

this information is located on the specification sheet that comes with the monitor and display card. It is even better if you can get an adapter card capable of higher resolution. We use a 1600 x 1200 resolution card to get some incredible image quality on our 19" editing screen.

CD/DVD. Most computers today come with either a CD or DVD player as part of the system. These devices are great for retrieving files, but you will need an archival storage device for saving your edited images. If you have very many, you won't want to leave them on your hard disk for very long. We

T H E R E ' S M O R E ?

You will be editing images for long periods of time so you need to make yourself comfortable. The room you work in needs to have minimal lighting. You don't want to work in the dark, but your computer screen should be the dominant light source. You need to keep the lighting constant each time you edit or slight variations will show in your editing. A comfortable chair, preferably with a high back, reduces fatigue when using your computer.

Now that you are comfortable, let's make your *computer* comfortable. Sounds silly doesn't it? You need to streamline your computer system in order for it to operate at maximum capability. This means removing screen savers, startup shortcuts and all the fancy decorations that really don't have anything to do with image editing. In other words, streamlining your machine to make it lean and mean. We keep our editing machines operating with at least 95% of their memory before ever loading any editing programs.

archive all our images to CD using an internal CD writable drive. We will discuss this image storage problem in greater detail later in chapter 20.

Mouse. When you are doing image editing, you use your mouse often. You need to learn how to care for and feed your mouse. Most people get really frustrated when their mouse starts to get jerky on the screen. This can be really frustrating and slows down the editing process considerably. Over time, dust and hair roll up into the mouse and wrap around two drive wheels. If you turn the mouse over, you can remove the ball and clean the two rollers. Often you only need to blow out the dust and dirt, but you can also remove the ball and clean it with soap and water. Put it all back together and you're in business again.

YOU NEED TO LEARN HOW TO CARE FOR AND FEED YOUR MOUSE.

Software

We stated that we are using Adobe® Photoshop® for all of our samples. Your selection of a photo editing software program does not have to be restricted to one brand. Since many have slightly different features, it may be necessary to have two or three different programs. We personally, use several programs to accomplish all the tasks at hand. No single program seems to include everything you would ever need when editing underwater pictures.

When purchasing software, look for programs that include a clone tool, gamma control, layers and

channels, batch control and the ability to import and apply Photoshop filters and plug-ins. It is also important that your editing program can interface with your photo database, use a color management system and is comfortable for you to use. Fortunately, many of the software manufacturers now have demo versions of their products on the Web for you to download and try. A more detailed explanation of the software editing tools is covered in chapter 5.

○ Output

Once you have imported your image into the computer and edited it to your satisfaction, you need to be able to export it from your computer. There are several different output devices that allow you to share your finished work with family and friends.

Inkjet Printer

When the digital world began, several types of output devices and media were tested on the consumer. Most failed, but one seemed to endure. The inkjet printer has now become as commonplace as the computer itself, and the quality of the inkjet image has now surpassed the quality of the traditional color print. Recently, the archival quality and image sharpness of inkjet media has increased to such a point that it is no longer measured against traditional print media. It has actually surpassed

THE ARCHIVAL QUALITY AND IMAGE SHARPNESS OF INKJET MEDIA HAS INCREASED.

photo prints and has become the new yardstick in output media.

The quality of the inkjet prints is excellent and will reproduce your underwater images beautifully. Keep in mind that the higher the dpi (dots per inch) rating on the printer, the better the print quality. You can easily find printers with over 1000 dpi in most stores and their cost is very little compared to just a year ago. Most come with their own color management drivers, and some even have bonus programs that help you put together printing projects such as calendars and greeting cards. Remember, the smaller the print output, the smaller the printer cost. If you only occasionally need a large print, it might be more cost effective to have a digital photo lab print those few large images, instead of spending the extra money to buy a large printer.

THE SMALLER THE PRINT OUTPUT, THE SMALLER THE PRINTER COST.

Film Recorder

The film recorder is a digital output device that outputs film instead of prints. When digital photography first started, the film recorder was a critical element that allowed the creation of new transparency images for slide presentations, offset printing and stock photography. Recently, the demand for slide output from the computer has dropped drastically. Slide usage is now at an all time low of 1% compared to the 96% usage of color negative film in the amateur marketplace. If you do need to output to a film

recorder, there are several service bureaus that can create slides from your digital files.

○ Taking the Plunge

Making educated buying decisions is probably the most difficult part of getting into digital photography. The choices of hardware and software are limitless, and with technology improving so rapidly, it is hard to stay ahead.

If you have already begun taking pictures underwater, you have learned that nothing involved with underwater photography comes cheap. In order to make proper buying decisions, you must allocate a sufficient budget. You can prioritize your purchases

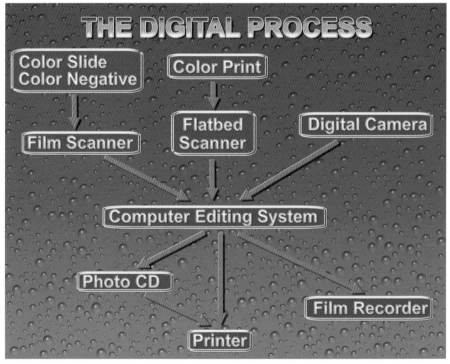

The digital process uses the in-edit-out concept that covers all types of digital imaging.

and make them one at a time rather than all or nothing. Throughout this book, we will continue to show you what tools will make your editing easier. Right now we need to move ahead and get you started scanning your images.

Scanning Your Underwater Images

T HE MOST POPULAR BRIDGE between traditional photography and the digital world is the scanner. A few years ago these electronic marvels cost more than most pocketbooks could bear. Even if you could afford one, they were difficult to use and it was really tough to obtain a good scan. Today's scanners are inexpensive, produce sharper images,

TODAY'S SCANNERS ARE INEXPENSIVE AND PRODUCE SHARPER IMAGES.

run quickly and are much easier to set up. Even the software used to run scanners has become so efficient and easy to use, that it no longer is difficult to make good scans. Unfortunately, there are many aspects of scanning that software and hardware manufacturers don't always tell you. Over the years,

More than 100 different types of slide and negative film are available for underwater photography. The best film speed choices for underwater photography are from ISO 100 to ISO 400.

we have collected a notebook full of scanning problems and their solutions.

○ Film Choices for Scanning

You can use slide or color negative film in your film scanner. Many scanners even have an attachment that allows you to scan your APS film. Scanners have different sets of internal specifications for scanning the various slide and negative films.

YOU CAN USE SLIDE FILM OR COLOR NEGATIVE FILM IN YOUR FILM SCANNER.

Each color negative film has a different color balance when printed on traditional color paper, so it is not surprising that the same thing happens when they are scanned. Fortunately, many of the new films

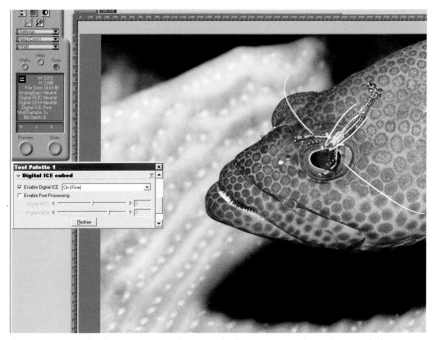

Preview image of color negative with negative cleaning control panel expanded.

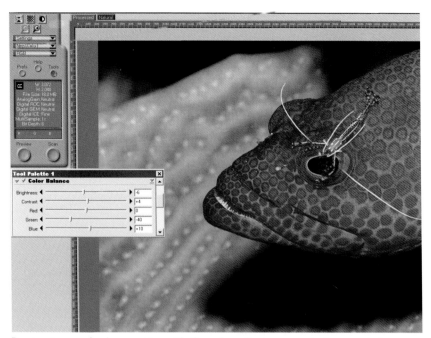

Preview image of color negative with the color adjustment controls expanded.

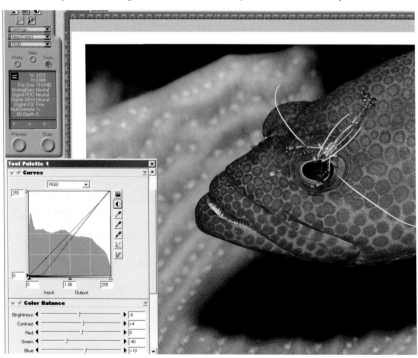

Preview image of color negative with gamma curve editor expanded. Auto correction is located in this control panel.

belong to film families, so the color balance for each group usually can be used for all members of the film family.

Most film scanners on the market today include a list of the most popular film types and their specifications that will get you close in color. You don't

This is what a typical underwater color negative looks like before it is scanned. The orange mask is used as part of the color printing process, and is removed during the scanning process.

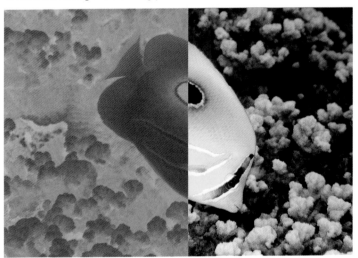

This image shows half the color negative before it is scanned and half after the negative has been run through the scanning process.

When a color negative is scanned, the color mask is removed and the image is reversed, resulting in a positive image.

have to have a perfect color balance at this point, because you can make all your final color corrections using your photo editing software.

Slides

Color slide film is normally the traditional underwater photographer's final product. Slides produce a positive image that can easily be analyzed to determine if you have achieved a good exposure or correct color balance. There is little doubt as to the colors you recorded in your images when you can directly view them on a lightbox or with a slide projector.

USE THE POSITIVE SETUP FOR THE SCANNER AND YOU SHOULD BE REALLY CLOSE.

When you place a color slide into a film scanner, use the positive image setup for the scanner and you should be really close on the first pre-scan. The only

exceptions are with Kodak Kodachrome films. These films use a different type of final coating and will usually turn blue on the first pre-scan. Once you tweak your settings to achieve a balance, be sure to save the adjustments as a special slide setting. Next time you need to scan a Kodachrome, just select that setting and your color balance should be close.

The down side to scanning color slides is that their density ranges from very dense black to very clear white. For the scanner to capture the full range of the color slide, you must insure that you are in the middle of the slide's exposure range before you scan it. With most slides scanners, the default setting will lose some shadow detail in the original

THIS CAN BE OVERCOME BY USING THE GAMMA CONTROL SETTING IN THE SCANNER.

slide. Not to worry—this can be overcome by using the gamma control setting in the scanner. This provides a visual representation of the tonal curve. We will discuss gamma in depth in chapter 7.

Slides also tend to lose a bit of image resolution in the scanning process. Although scanners do have sharpening controls to counteract this loss, we recommend using the more sophisticated sharpness control found in your photo editing programs.

Color Negatives

Color negative film is not the final image and must go an additional step to create a final print on paper. The colors you see on the negatives are inverted and muted by an orange mask. It is very difficult for even

LARGE FORMAT SCANNING

Large format film can be scanned on high-end flatbed scanners equipped with a transparency option. Recently, several manufacturers have also introduced film scanners that can scan transparencies in the 2¼" x 2¼" and 4" x 5" formats.

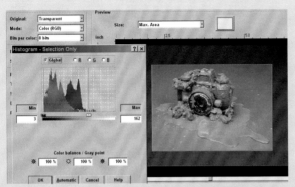

Flatbed scanner edit screen with large format film image controls and preview image.

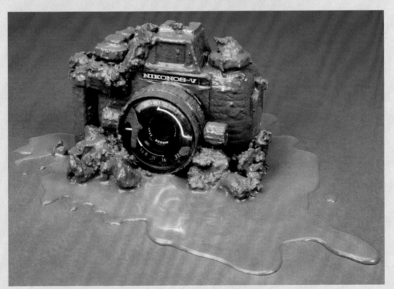

Final scan of a large format image on a flatbed scanner.

the most advanced photographer to determine just by looking at a processed color negative if correct color balance and exposure has been achieved. Usually, printing the negative is necessary to make

that determination. This lack of color reference is why it is difficult to determine correct color balance on scanned color negatives.

Color negative film has a much greater exposure range than color slide film. This makes it easier for the film scanner to capture the density range that provides smoother color gradations. The downside is that color negative film has larger grain than slide film, which becomes more pronounced as it

COLOR NEGATIVE FILM HAS LARGER GRAIN THAN SLIDE FILM.

goes through the digital process. This is especially true if you use the sharpening tools in your editing software. The key is to use slow films with low ISO ratings and finer grain.

○ Scanning and Color Management

Color Balancing Your Monitor

The computer monitor is your visual connection during the scanning process. If it is not correctly

A wide variety of monitor balancing controls come with higher-end software programs. These menus illustrate how you can adjust the gamma, contrast and brightness of your computer monitor.

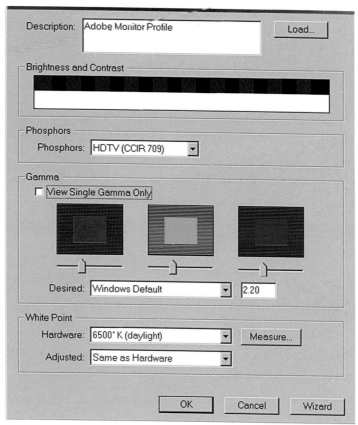

Individual gamma controls for red, green and blue in Adobe Photoshop. If you have trouble with a basic color shift from one system to another, this menu may help you solve the problem.

matched to both your scanner and output devices, your results will be inconsistent.

Until recently, setting up a monitor was a hit and miss proposition. Most software packages had a simple program for balancing the gamma, but that was about as far as it went. Today, most editing software programs like Photoshop, offer a gamma loader/monitor setup program to help you quickly get your system in line. This program adjusts the

UNTIL RECENTLY SETTING UP A MONITOR WAS A HIT AND MISS PROPOSITION.

Typical gamma control menu found in a film scanner.

brightness, gamma and color balance using software controls.

Once you have your monitor balanced, make sure no one touches its controls. Someone playing computer games and adjusting the monitor can wreak havoc with your scanning process. Eliminate excessive window light, avoid any dominant color surrounding your editing area, make sure you let your monitor warm up before using it and use the same low light conditions every time you edit. It is often helpful if you set a color chart near your editing area to give you a neutral reference point.

Software Controls

If you have never used a scanner before, the software controls may be overwhelming. Believe it or not, the best way to learn how to use a scanner is by reading the instruction book. What a novel idea! The help functions can answer many nagging questions, but you really learn by practice. The more comfort-

able you are with your system, the more quickly you will be able to perform the edits.

When you first set up your film scanner and related software, you will find that there are two ways to access and scan images. The image editor plug-in software works out of the program you plan to edit with and scans the image directly into the editing program. This is great when you scan only one image at a time and plan to edit it immediately.

The second method for scanning film is with a stand-alone program. This program is unrelated to any editing program and scans images and saves them to the hard disk. The advantage to the stand-alone is that it uses less memory than the combined plug-in plus editing program, and usually runs more efficiently. We like to set our film scanner for fifty slides and have them saved to the hard disk for editing. This requires a large hard disk, but with the new high-quality image compression programs and cheap hard disks, space is no longer a problem.

THE SECOND METHOD FOR SCANNING FILM IS WITH A STAND-ALONE PROGRAM.

Start by scanning a slide, since these are much easier and you will have a visual reference point. Play with all the controls—change the contrast, brightness and modify the color balance. You don't have to achieve perfection, just get the preview close to what you want. We feel that the controls in the editing program are generally better than the scanner's, so fine-tuning should be done during the editing process.

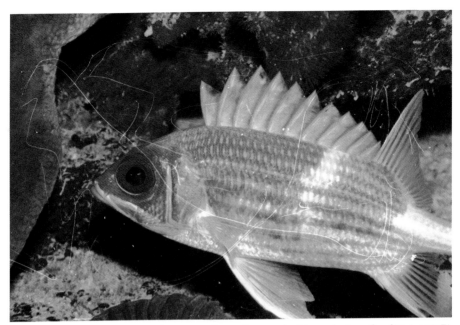

This color negative was damaged in processing and scanned without the benefit of Digital ICE™ technology.

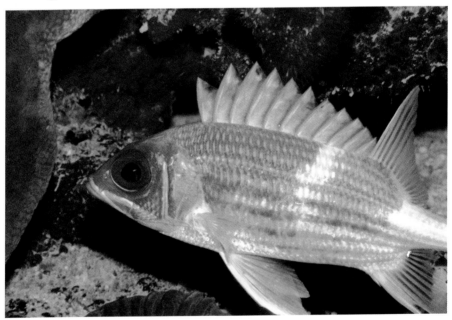

The color negative with multiple scratches was scanned with Digital ICE™ technology, removing the scratches and cutting down on editing time.

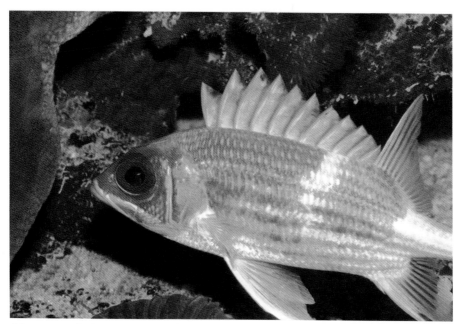

After a scratched image is scanned with Digital ICE™ technology, any remaining artifacts can be removed with the clone tool. More on the clone tool and scratches in chapter 10.

Typical preview scan of color negative before any adjustments. Gamma controls are to the left of the preview image.

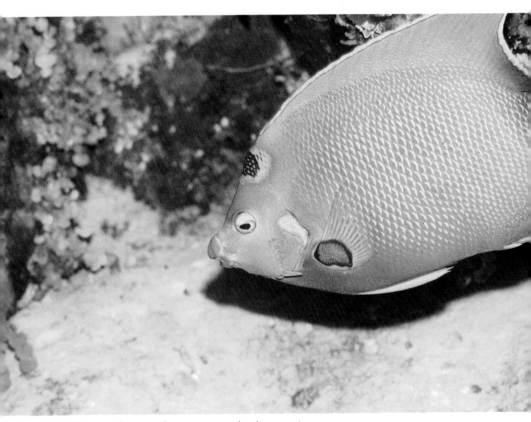

Full scanned image of an uncorrected color negative.

Preview image of color negative with corrections to color and gamma using the scanner image controls on the left.

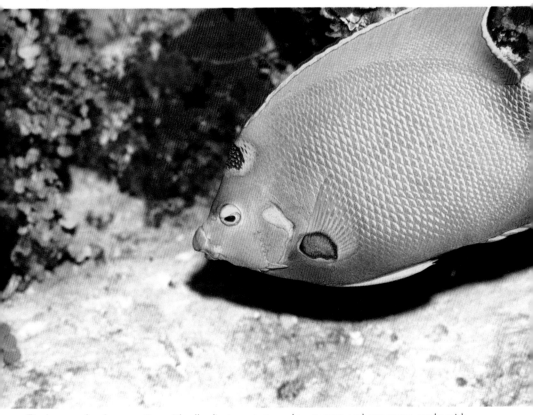

Final scan of color negative with all adjustments to color, gamma and exposure made with scanner controls.

Color Management Software

Probably the most confusing part of a scanner is the color management software included with most of the newer film scanners. When you first set up your scanner, you may be given the choice of using color management software. If so, just go ahead and use the default setting. Once you begin to understand exactly how it all works, you can try changing some of the settings. This color management software's purpose is to keep a record of how your system manages color and help you maintain the same

THE MOST CONFUSING PART OF A SCANNER IS THE COLOR MANAGEMENT SOFTWARE.

Most film scanners have a color management menu to match the color management system in your editing program. Start with the default, which is usually the sRGB color management profile.

color balance from input to the final output. Some file types even include your color management profile when you save the file. This allows you to send the file to someone and have computer easily see how your computer managed the color. It can then translate the colors accordingly.

Scanning Cleanliness

Once you have corrected any color balance variations, most of your editing time will be spent removing dust and scratches from your scanned images. It saves time and energy if you properly clean your images before they are scanned. We use both a negative brush and compressed air to clean each image. The brush is used first to knock the dust loose. We then blow it off with the compressed air. If there are particles embedded in the emulsion, we leave them alone and edit them after the images are scanned. Keeping your scanner covered when not in use and cleaning it often will help eliminate dust problems.

MOST OF YOUR EDITING TIME WILL BE SPENT REMOVING DUST AND SCRATCHES.

Sharpening

Since your image loses a slight bit of resolution during the scanning process, you generally need at least one sharpening pass before you save the file. You have the choice of sharpening the image during the scan or during the editing process. We highly recommend sharpening the image during the editing

process for several reasons. It generally does a better job, you can experiment with different levels of sharpness and if you don't like it, just press the undo. Be sure that you don't over-sharpen your image, as that quickly makes it a victim of improper digital image editing.

○ Editing Tools

Most scanning software makes the assumption that your image has a full tonal range from black to white. Underwater images predominately have dark backgrounds and often lack full tonal range. As nice as it would be, you should never assume that your underwater images will scan in perfectly. That's why you have an editing program!

NEVER ASSUME THAT YOUR UNDERWATER IMAGES WILL SCAN IN PERFECTLY.

Most photo editing programs have excellent editing tools. Take the time to learn how to use the gamma, white point, black point, histogram, unsharpen filter and clone tools. Use these editing tools to increase shadow detail, make the blacks blacker, or adjust the highlights to better represent what you actually saw underwater.

Compare the final image to the original that you scanned. If the scan doesn't match your expectations, tweak it some more, or start over. Like everything else in life, it takes practice to achieve satisfactory results. The advantage with scanning and editing is that you have the luxury of the undo function, which will quickly become your best friend.

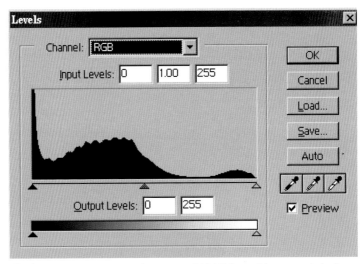

The histogram menu is used to control highlights, midtones and shadows with small triangle-shaped devices at the bottom of the graph. This menu is found in Adobe Photoshop.

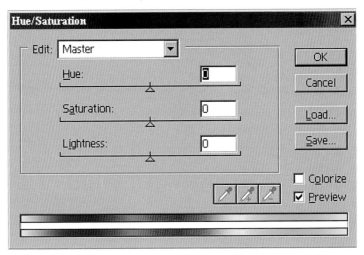

The hue/saturation control is used to increase/decrease saturation in images that are over- or underexposed and have drastic changes in color saturation. The hue and lightness functions can also help with the saturation adjustments.

Digital Resolution

THE NUMBER ONE QUESTION underwater photographers ask us is at what resolution they should scan their images. In each case, we immediately asked them what they will be doing with the images. We then give them our resolution recommendation only to find that they totally ignored our advice and scanned the images at maximum resolution.

THIS SEEMS TO BE TYPICAL OF PHOTOGRAPHERS GETTING INTO DIGITAL PHOTOGRAPHY.

This seems to be typical of many photographers getting into digital photography. When asked why they scanned at the highest resolution, they say that they didn't want to cut corners on quality. They initially used the best film, so why shouldn't they use the best resolution with their scanner?

○ Resolution

With traditional photography, you can use the same 35mm negative or slide to print 4" x 6", 5" x 7", or larger prints. The time it took to shoot the image is the same for all print sizes, and the image resolution remains constant since you use the same negative. With digital photography, an increase in image resolution will raise the time and money necessary to create the digital image. As the image resolution

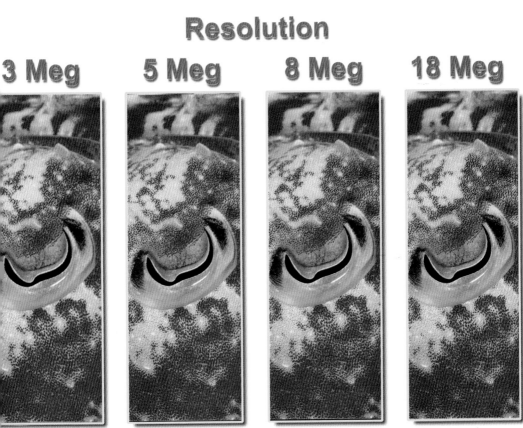

Comparison of the same image at various resolutions. Most digital cameras are at the 3–8MB file size, while film scanners run from 8–18MB in size.

increases, the digital image takes longer to scan, edit and output.

Perception of Quality

Quality is in the eye of the beholder and the perception of quality is totally subjective. What *we* think is acceptable may not even come close to *your* quality expectations. It is true that today's technology has created better hardware and software, thus raising digital image quality to the level of the traditional photo prints.

There are many who feel that you should scan in all your images at the maximum resolution your scanner offers. Sounds good, but that means that all your files will be huge, creating a storage nightmare! The problem is that you don't always need the highest quality possible. You need to match

ALL YOUR FILES WILL BE HUGE, CREATING A STORAGE NIGHTMARE!

the quality level with your end product. The quality of the image is directly proportional to the file size of the original scan.

Pixel Dimension

A pixel is the smallest unit of measurement on the computer screen. These pixels should be considered the "grain" of the computer screen image and can be manipulated the same way that grain in film can be changed and improved. The overall resolution of an image is measured by dots per inch (dpi) or pixels per inch (ppi). Monitors, scanners and printers usu-

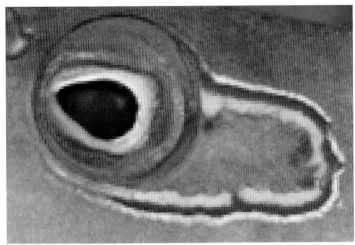

Extreme enlargement of fish eye showing the pixelation at each specific resolution.
TOP: 512 x 240 pixels.
CENTER: 1024 x 682 pixels.
BOTTOM: 2048 x 1365 pixels.

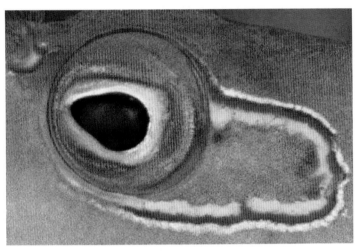

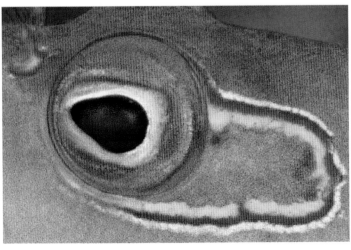

ally refer to dpi, while photos use ppi to describe the number of pixels in the entire picture. You will often find the resolution described by the number of pixels along the width and height, such as 1280 x 1460.

Scanning Resolutions

When deciding at what resolution to scan in your images, you must look to the final output for the answer. If you are going to make a 16" x 20" print for your final output, then you are going to need to scan in your image at the highest resolution possible with your scanner. On the other hand, if you are only looking to put your images on the Web, then you want a low resolution scan so that your final image opens or loads quickly. Unfortunately, there is no universal chart showing the scan resolution necessary for all applications. We devised a simple standard that seems to work . . . at least most of the time. These numbers represent the working numbers attached to the file itself at the time of the scan.

WE DEVISED A SIMPLE STANDARD THAT SEEMS TO WORK.

LOW QUALITY SCAN—final page size at 72 dpi

MEDIUM QUALITY SCAN—final page size at 133 dpi

HIGH QUALITY SCAN—final page size at 266 dpi

This may seem confusing because you will see film scanners advertising that they scan at 2700 dpi. You need to remember that this dpi is at 100% (or 24mm x 36mm for a 35mm). In order to scan the neg-

ative for a final output to an 8" x 10" print, the dpi would decrease proportionately with the increase in image dimension.

The two pieces of information that will give you an accurate value of an image's resolution are pixel dimension and file size. If the photo is a black and white grayscale, you can multiply the vertical and horizontal dimensions and you will get the approximate file size. Three times that will be close to the

TWO PIECES OF INFORMATION WILL GIVE YOU AN ACCURATE VALUE OF RESOLUTION.

Resolution for 8 X 10 Print
72 dpi 133 dpi 266 dpi

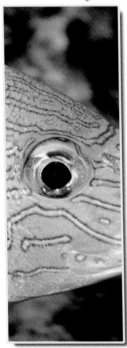

The dpi, or dots per inch, of a digital image increases in proportion to the quality of the image.

RGB image size. Multiply it by four and you will have the CMYK file size.

Rescan to Change Page Size or Dpi

If you need to make minor changes to page size or dpi, you can usually do it with the page setup in your editing program. Simply change the image page parameters and it generally won't affect image quality—especially if you reduce the page size or dpi. If the change is more involved, then you may have to make a new scan to maintain quality.

IF THE CHANGE IS MORE INVOLVED, YOU MAY HAVE TO MAKE A NEW SCAN.

Comparison of a high resolution underwater JPEG image at 2MB to an Internet version that has been scaled and compressed to 44K.

Scanning for the Internet

It is becoming increasingly popular to scan images to send via e-mail. This allows friends and family members to see your special underwater images shortly after you finish your dive. But, there is

nothing more frustrating than sitting waiting for images to load on your computer. When scanning images for the Internet, make sure they are less than 640 x 480 to minimize download time. You will find that this image quality is more than acceptable for Internet image viewing.

If you already have a higher resolution scan and want to use it on the Internet, simply resample the image to a lower resolution. After making any large changes, it is critical that you use a sharpening filter to correct the quality loss. Raw, resampled images are less sharp than the same images scanned directly in at a lower resolution.

Scanning for Inkjet Printers

Low equipment prices and increased paper quality have vastly increased the popularity of inkjet printing. It is now financially feasible for every computer owner to have an inkjet printer sitting on their desk. This is a great improvement because it allows underwater photographers to create economical prints in the privacy of their own homes. There are no more excuses for why you don't have prints decorating your walls at home and the office.

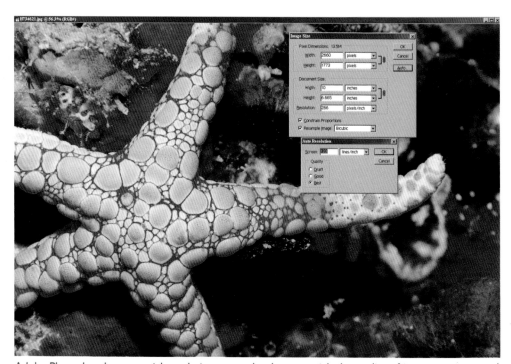

Adobe Photoshop has a special resolution menu that lets you pick the quality of image you want and the program fills in the blanks. Here, best resolution.

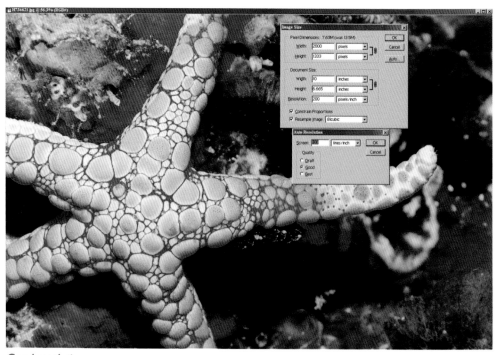

Good resolution.

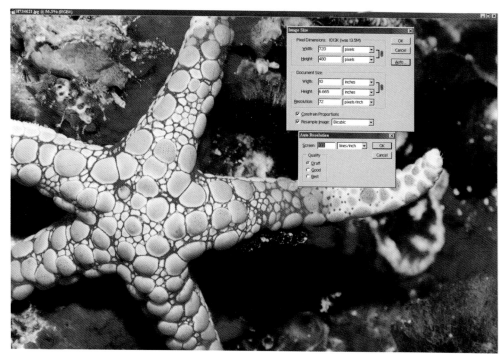

Draft resolution.

Digital files can also be compressed to reduce the space required to store them (or the time to download them). This can result in reduced image quality. Fractal compression software does a much better job of compression with high resolution files, but takes longer to compress and uncompress files. Fractal compression on the left and JPEG on the right.

Everyone has a different perception of the quality level necessary for scanning images for output on inkjet. The best way to find your level of acceptability is to run tests using different resolutions at various print sizes. If you don't want to take the time to run tests, then here's a list of the output resolutions and print sizes that we use in our lab.

INKJET PRINT SIZE	LONGEST PIXEL DIMENSION	REQUIRED FILE SIZE
8" x 10"	2000	8MB file size RGB
11" x 14"	3000	18MB file size RGB
16" x 20"	4000	34MB file size RGB
Lager than 16" x 20"	8000 (or more)	128MB (or more) RGB

As you see, the scanning resolution is closely tied to the quality of your final outcome. By now you know how to scan in your images at the resolution required for your desired output, so it is time for us to move onto the next chapter on editing your images.

Photo Software Basics

BEFORE YOU CAN START EDITING your underwater photos with accuracy and efficiency, you need to learn the basic software editing tools and understand how they work. These tools are not really difficult to learn to use, it just takes time and practice. The key is to push all the buttons, read the

THESE TOOLS ARE NOT REALLY DIFFICULT TO LEARN TO USE.

manual, practice using test images and take advantage of the help function. Before long you will be amazed how this knowledge will enable you to quickly improve your underwater images.

○ Adobe Photoshop

As we mentioned, for continuity throughout this

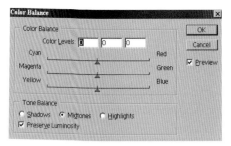

The color balancing menu allows you to adjust each color for shadows, midtones or highlights. Move the slider to the left or right and the color change is displayed in your image.

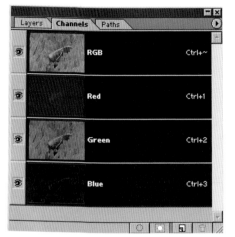

Layers and color channels can be viewed at any time during an edit session by selecting the layers/channel palette. Once it is opened, you can select an individual layer or channel and apply specific editing to only that object.

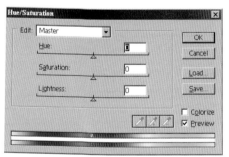

The hue/saturation menu is a basic slider menu that allows you full control over hue, saturation and brightness. Adjustments are made by moving the slider left or right in the menu.

The variations menu uses a standard ring-around system. The middle image is the color of your present image, and the images around it are different color variations. Selecting any of these variations puts the new image in the middle and a new set of variations appear around it. You can adjust brightness with the side menu.

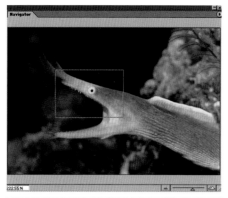

The navigator menu is a visual method for zooming in on a specific area in an image. Use the mouse pointer to select any area, and the new zoom area appears. The navigator menu then gives you a selection box in the full image showing you the zoomed area.

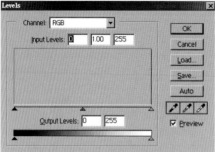

The levels editor is used to adjust shadow, midtone and highlight detail in your image.

The shapes menu (above) and styles menu (right) allow you to add basic shapes and text with special effects as a layer on top of your main image.

So why not put the controls up where you can see them all simultaneously? With several hundred possible tools to use, even a small icon representing each would completely cover the screen. This would leave no room for image editing, so most controls

remain hidden until you need them. It is important that you learn where these controls are and the importance of each in editing your underwater images.

○ Filters

Most software editing programs today also have a variety of creative tools called filters or plug-ins. These control the special effects part of your editing program. With these filters you can sharpen an image, add lens flare, posterize it, convert it to black and white, or thousands of other creative effects.

Deep walls off San Salvador island allowed us to produce this dramatic stock image on color negative film. It was then scanned into the computer for special effects. The posterization filter was used to decrease the number of colors in this image to less than a half dozen, producing a new image.

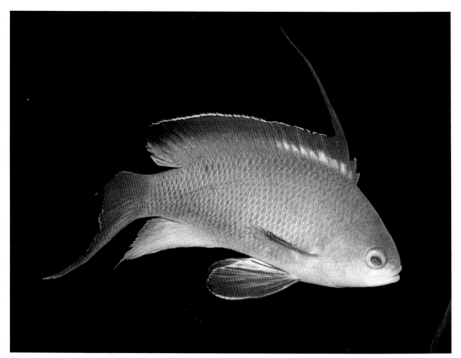

Stock image of a Fijian fish. Shot on high speed color negative film and scanned at 8MB resolution.

A special plug-in filter called a Vortex Tile was used to create many fish from a single fish image.

○ Actions

One of the most powerful controls in an editing program is the macro or actions function. If you have repetitive tasks, you can record each step in a special file. Then when you have to repeat the task again, just apply the action and it does all the work for you. You can also have it apply the action to a group of images to maximize task savings.

Let's say that you have scanned and edited a hundred images, and are ready to archive them to CD. You want to convert them to 300 dpi JPEG files in a

The actions menu is a method for automating those tasks that you do over and over. Start the record function, go through the procedure once and stop the recording. From that point on, a hot key will activate the recorded function and apply it to your images.

new directory. Simply start the actions recorder and perform all the required actions for one file. Close the action and then apply the new action to the entire directory of images. The program will then load each file, change it to 300 dpi, and save it to a new directory as a JPEG file. Best of all, this all happens unattended, so you can be in the next room watching *Sea Hunt* reruns.

○ What's Ahead?

In the following chapters we will look at the most commonly used tools for editing underwater images. We can't cover them all, as there are too many to feature in the space allotted in this book. If we don't mention one you need to use, simply pull down the help function and type in the tool's name. If that doesn't provide satisfaction, you could always resort to reading the manual (believe it or not, it really does help).

FACING PAGE: The toolbox in Adobe Photoshop is the center of your workplace. Most of the editing tools you will need are in the toolbox. Each tool is represented by a small icon. When you pass your mouse pointer over the icon, a small information menu will appear, explaining the tool's function. You can also touch the small triangle in the lower right corner, and a flyout menu will expose additional tool groups under that one icon. You can then select a specific icon, and it will become the new toolbox icon.

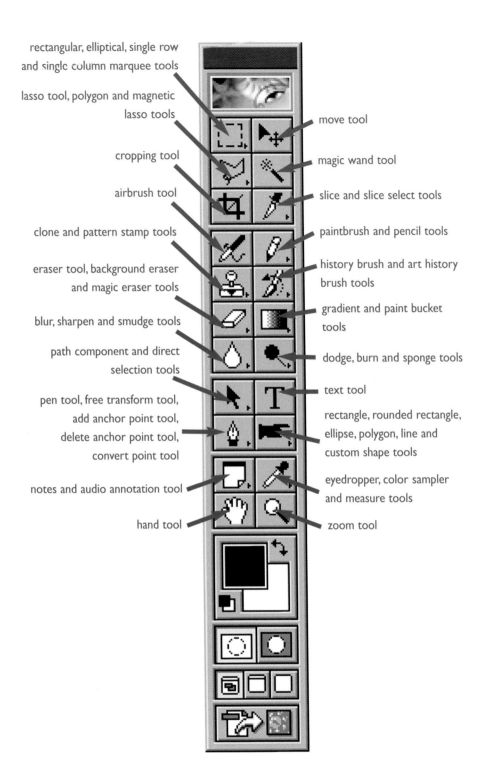

rectangular, elliptical, single row and single column marquee tools

lasso tool, polygon and magnetic lasso tools

cropping tool

airbrush tool

clone and pattern stamp tools

eraser tool, background eraser and magic eraser tools

blur, sharpen and smudge tools

path component and direct selection tools

pen tool, free transform tool, add anchor point tool, delete anchor point tool, convert point tool

notes and audio annotation tool

hand tool

move tool

magic wand tool

slice and slice select tools

paintbrush and pencil tools

history brush and art history brush tools

gradient and paint bucket tools

dodge, burn and sponge tools

text tool

rectangle, rounded rectangle, ellipse, polygon, line and custom shape tools

eyedropper, color sampler and measure tools

zoom tool

Basic Image Adjustments

WHEN YOU FIRST LOAD AN IMAGE for editing, take a quick look and make a note about your first reactions. Very rarely will an underwater picture scan in perfectly. Water density reduces light intensity, shifts the color, lowers the contrast and decreases the color saturation. That's a lot of things to happen to one underwater image. Before the computer came along, there was not a whole lot you could do to fix the problems. A few darkroom technicians could work wonders on an image using traditional methods, but the time and expense usually exceeded the underwater photographer's pocketbook. With today's sophisticated computers and

THAT'S A LOT OF THINGS TO HAPPEN TO ONE UNDERWATER IMAGE.

photo editing software, you can now accomplish miracles with just a few key strokes.

○ Auto Level

The first adjustments you will need to perform on your images will probably be regarding exposure, contrast and color balance. Photoshop has instant help for you when you access the image adjust pull-down and select the auto levels function. The program automatically adjusts color balance, contrast and brightness. Sometimes the computer makes the right choice and other times it is way off in left field. Topside photos auto balance most of the time,

SOMETIMES THE COMPUTER MAKES THE RIGHT CHOICE, OTHER TIMES IT IS WAY OFF.

but underwater images rarely have a full spectrum of color from black to white, so they are much harder to balance. Give the auto levels a try first and if you don't like what the computer selected, then simply press the undo and move on to plan B.

○ Variations

In the same image adjust pulldown menu, you will find a function at the bottom called variations. When you select this function, a special screen called a ring-a-round is formed. Your image is displayed in the center with color variations circling it. If you select a color variation that looks better than your original, it then moves to the middle and a new ring of colors forms. You can keep selecting different color variations until your image looks just right.

To the side of the ring, you will find three exposure variations. Your image is in the middle and a lighter and darker image are displayed above and below. When you select one of the exposure variations, it then moves to the center and becomes the new image. At the top of the screen you will find a copy of your original image and the last change you made featured side by side for easy comparison.

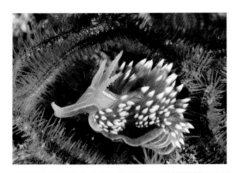

This California Nudibranch has a very cold color shift that can be corrected with the variations menu.

The variations menu uses a standard ring-around system. The middle image is the color of your present image and the images around it are different color variations. Selecting any of these variations puts the new image in the middle. A new set of variations then appear around the center image.

The image from the lower-right portion of the ring-around was moved to the center, creating a new color balance. The brightness was increased by dragging the upper image in the brightness panel.

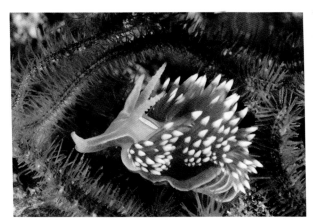

The final corrected image using the variations menu.

When you first start editing images, it is best to use this variations method when making corrections to exposure or color. This is a great learning tool because you can easily see the effect each selection will have. Choosing the correct color balance and exposure is very subjective and is an acquired skill that often takes time to hone, so have patience.

○ Manual Method

As you become more proficient with image adjustments, you will want to progress and try adjusting images manually. The color balance, brightness and contrast controls are adjusted using a set of sliders that surround your original image. Make sure the preview box is checked so that each effect is immediately displayed on the screen. Most underwater images have a cyan cast, so if you move the cyan slider toward red, you will see an immediate improvement. Take some time to play with all the sliders and see how each affects your image.

One of the best ways to learn how to use these sliders is to select an image that worked with the

auto levels function. Make a copy of the original file, and see if you can manually correct the color, contrast and brightness so that it looks like the image that was auto corrected. Just as it takes time for a musician to learn how to play an instrument, it will take time for you to learn how to correctly balance underwater photos. Be patient, as it may seem frustrating. In time it will become second nature.

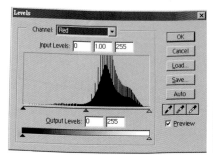
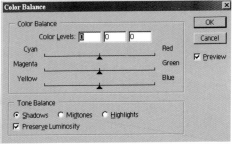

When you first start working on a digital image, you will use either the levels menu (left) or the color balance menu (right) to adjust the colors in the highlight, midtone and shadow areas. Both accomplish the same thing using a different approach to the problem. In both menus, you use sliders to adjust the specific attribute of the image.

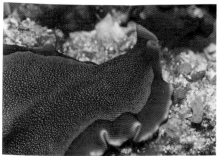

Off-color scan of colorful flatworm. The warm color cast could be due to the scanner not being set up right, or problems with the original image itself.

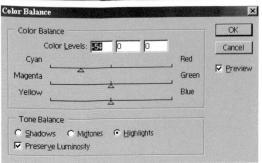

The first step is to find either the levels editor or the color balance menu under the adjust pulldown menu in Adobe Photoshop.

In the levels editor, you can use the sliders to adjust each color channel.

The first adjust is with the red shadow slider. Moving the slider to the left will decrease the darker red shifts.

The second adjust is to the red highlights. Moving the slider to the left will shift the color to a more cyan tone.

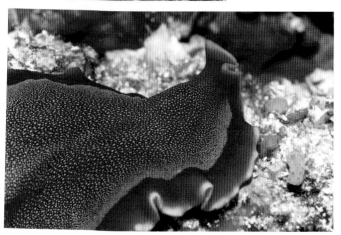

The final flatworm image with adjustments made to both the red shadows and highlights.

○ Saturation

Underwater color images tend to lose color saturation as the subject increases its distance from the lens. This can be corrected by using the saturation function from the image adjust pulldown. Be careful, because the tendency for new image editors is to increase the saturation too much. A good starting point is 10%–15% adjustment. The best way to see how this control affects your image is by printing comparisons on your inkjet printer and laying them side by side.

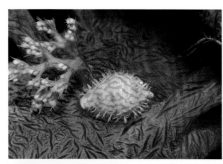

Original scan image of a Fijian cone snail that is too low in color saturation.

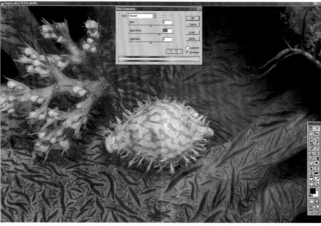

This image is split in half showing after saturation adjustment and before. The saturation menu is in the upper portion of the image.

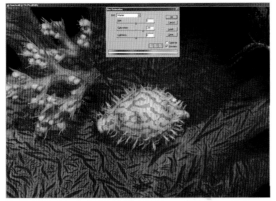

The color saturation of this image has been increased by moving the center slider to the right to +41.

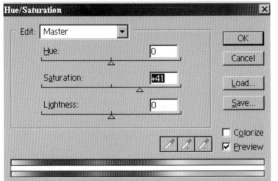

The saturation menu also includes hue and lightness controls. When you start working with saturation, you may find that you will have to make slight adjustments with these two controls.

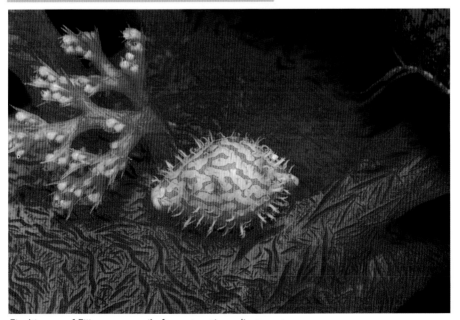

Final image of Fijian cone snail after saturation adjustments.

Photographic Curves

EVERY PHOTOGRAPH IS BROKEN DOWN into a curve that plots the image's density *vs.* exposure. The ratio of the density (Y axis) to the exposure (X axis) on the curve is called the gamma. An image with good whites, midtones and excellent shadow detail has a good photographic curve. Sad to say, not all underwater pictures have good photographic gamma. So, what do we do?

NOT ALL UNDERWATER PICTURES HAVE GOOD PHOTOGRAPHIC GAMMA.

Thankfully, your computer software can now help you fix some of the problems that occur with underwater photography. Once an image is scanned into the computer, you can now bend photographic curves with your bare hands! The gamma control is

one of the most powerful tools for adjusting under-
water images. Four controls are found under the
image adjust pulldown: levels, auto levels, auto con-
trast and curves.

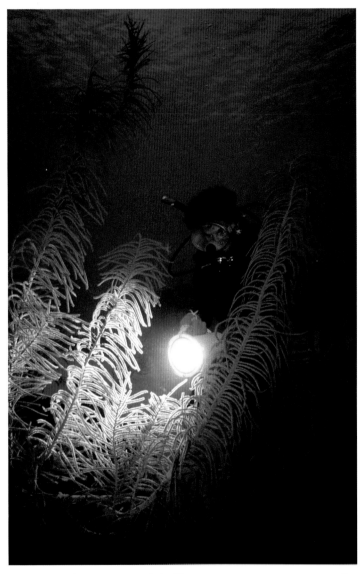

Color slide of diver with dive light. The gamma range was too extreme for
a good scan.

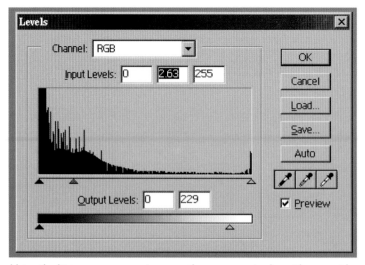

Using the histogram you can increase the exposure in the midtones without overexposing the highlights. Move the middle slider to the left and you have solved the problem.

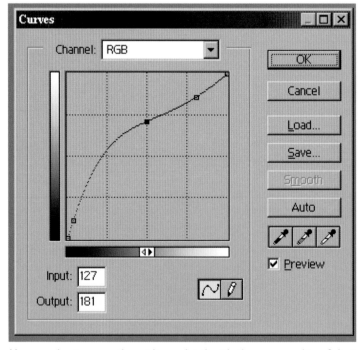

You can also increase the midtone detail with the curves editor. Select a couple of points along the curve and raise the midtone detail until it looks good on the screen. This function works very much like the histogram.

○ Levels

The Levels function allows you the option of using a histogram, sliders, or an eyedropper to adjust the gamma. A histogram is a visual representation of all the digital data contained in an image displayed from black to white on a scale from 0-255. It can either display all the color channels at once in RGB, or one channel at a time as R (red), G (green) or B (blue). You then can either adjust one color channel at a time or all the curves at once.

When you first bring up the histogram, look to see if your image fits within the full digital data range. At the bottom of any histogram you will find three sliding triangles that control the shadows (left slider), midtones (center slider) and the highlights (right slider). These sliders can be moved to adjust the gamma. Often the scan may not be perfect, and the data may fall short of the maximum allowed. You then need to look and see if the shadows in the image fit in the digital data range. Often, there is a small space at the left with no data.

LOOK TO SEE IF YOUR IMAGE FITS WITHIN THE FULL DIGITAL CURVE RANGE.

In the Levels, if the black is not a pure black in the image, the data will start somewhere to the right of the black triangle. Using the mouse, move the left slider over until it approaches the black data in the image. When you release the mouse, all the data in the image will readjust to fit the photographic curve correctly. If an image is dark and the whites are

muddy in appearance, you can move the highlight slider to match the white data of the image, and it will again correct to fit the photographic curve.

Historical diving image of one of the first underwater video cameras. No flash was used, so the image is very cyan/blue in color.

Using the eyedropper in the levels menu, the midtone dropper was selected and touched to the side of the video housing. This readjusted the entire tonal range so that it appears as though a flash was used.

One of the most common problems with scanning underwater slides is that they will have good blacks and whites, but often lack shadow detail. This is where the middle slider comes in to play. When you start to move it to the left, all the midtone data are shifted so that the detail in the darker area is lighter. If it is too light, move it to the right. You can also use the midtone pointer to select an area that you want to be the middle of the curve. Once you do this, the remaining data will automatically fall in place. Care must be taken not to over correct the midtone value. If you run a test print showing the effect before and after making the adjustment, you will see just how this correction affects the overall image.

If you know of a specific area in an image that should be black, white or gray, you can use the eyedropper to adjust the curve. For example, if you have a picture of a colorful fish that appears too dark. The area around the eye appears as a muddy white and it should be bright white. Take the

IMMEDIATELY, THE CURVE OF THE IMAGE WILL READJUST ACCORDINGLY.

white eyedropper located on the right side of the eyedropper menu, and touch the area of the eye that should be white. Immediately, the curve of the image will readjust accordingly. You could have also used the black eyedropper to readjust the gamma if there was an area in the photo that you knew to be black.

This is an excellent tool for balancing images taken with available light. As you know, available

light images often lack contrast and have an overall bluish cast. Look for any area in the image that you know to be black or white, such as a wetsuit or coral head. Touch it with the appropriate eyedropper and the entire image will magically come to colorful life before your eyes. You may want some of your images to have a blue cast for effect, so care must be taken not to overuse this control.

Another method for changing highlight and shadow data is located at the bottom of the screen. It is not used very often, but it features the range of the photo in a straight line showing the shadows to highlights. When an underwater photo is overexposed, often the highlights become washed out. If you want to salvage the photo, you need to reduce the highlight exposure to simulate data or enhance what remains. The shadow adds density by creating gray area in the black, which is often necessary for offset printing.

TO SALVAGE THE PHOTO, YOU NEED TO REDUCE THE HIGHLIGHT EXPOSURE.

○ Auto Levels

The auto levels is a great shortcut that lets the computer perform all the operations we have just described. When you first start editing the gamma curve, press this button and view the results. If it is satisfactory, then you have just saved yourself a lot of time, and you can progress on to other editing functions. If the computer did a poor curve edit, simply select the undo shortcut hot key to eliminate the

computer's efforts. You are now free to manually edit the photographic curve.

This picture of a cold water eel is off-color and underexposed.

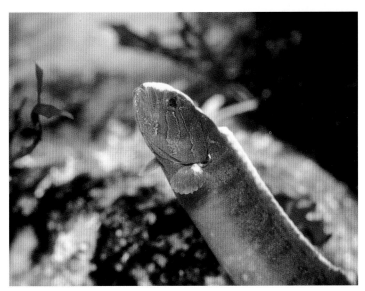

The entire correction to this image was accomplished using the auto levels function in Adobe Photoshop.

○ Auto Contrast

The next control is auto contrast. Often an underwater image looks off, so you immediately start adjusting the levels. Wait a minute, because you should try the auto contrast first. You will be surprised how many times all an underwater image needs is a contrast adjustment. After adjusting the contrast, you can always continue to adjust the levels if things didn't work out perfectly.

Low contrast image of a long-nose hawkfish in Fiji.

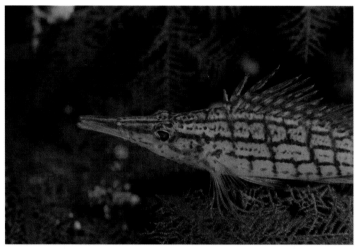

The auto contrast function was selected from the image adjust menu.

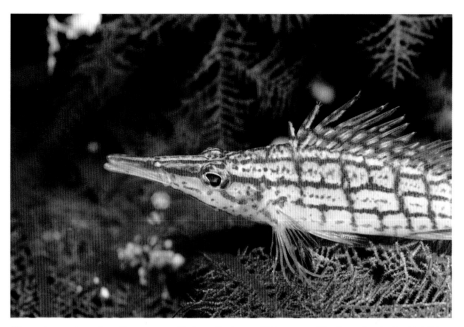

The auto contrast function was applied to the image. This control looks at both the highlights and shadows and readjusts them to match a standard photographic tone curve.

○ Curves

The last control, the curves editor, is the most complex and provides a standard digital photographic curve representative of your underwater image. The toe of the curve displays data about shadow exposure and the shoulder of the curve displays information about the highlights. Most of the data in photographic images is displayed in the middle of the curve called the straight line portion of the slope. The curve itself can be manipulated by grabbing any part and moving it. The resulting effect on the image is immediately displayed. If you need to fine-tune the editing, control points can be added to

THE TOE OF THE CURVE DISPLAYS DATA ABOUT SHADOW EXPOSURE.

the curve by clicking anywhere on the line. You can then grab a control point and the curve will bend around that point. The curve control should only be used by underwater photographers who have a good working knowledge of photographic curves.

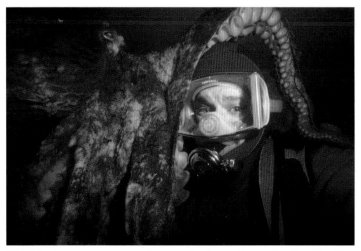

This Northwest octopus was improperly exposed on color slide film. The dynamic range of the scene was more than the film could handle.

The curve editor can be used to bend the midtones without affecting the remaining part of the image.

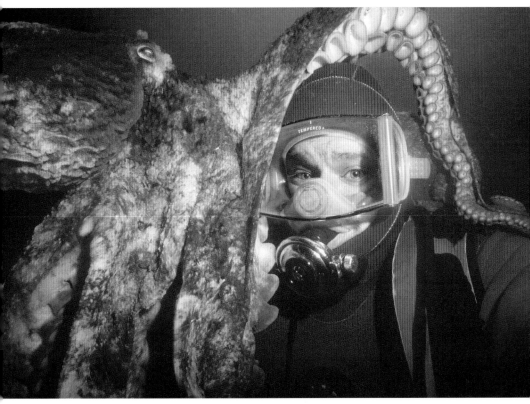

The final image after the photographic curve was adjusted with the curves editor.

○ Final Thoughts

The best way to learn how to use the gamma editors is to take several poor images and play with the editing controls until you feel comfortable. Remember, each time you make a change, the results are displayed. If you are not satisfied with the change, simply undo and try it again. Your only risk is the loss of time and pixels, but we think you'll agree that the results will be well worth the effort.

TAKE SEVERAL POOR IMAGES AND PLAY WITH THE EDITING CONTROLS.

Backscatter

ONE OF THE BIGGEST PROBLEMS facing underwater photographers is a phenomena called back-scatter. This occurs when the particulate matter in the water between the subject and the camera lens is illuminated by the flash. The result is

THE RESULT IS PHOTOGRAPHS WITH BRIGHT WHITE SPOTS.

photographs with bright white spots wherever the dirt was illuminated.

This problem is unique to underwater photography and is the villain responsible for ruining many potentially great photos. Even a single large backscatter particle downgrades the image quality. Before the computer came along, many of these images were sadly destined to have a home in the trash.

○ Clone Tool

Now, all that has changed with the arrival of computer software that boasts an anti-backscatter device called the clone tool. You will find this popular tool in the floating toolbox. Once you select it, all the necessary adjustment features will be available at the top of the screen.

The theory behind the clone tool is that the data you select with a circular pointer is then copied to wherever you move the cursor. The key to this process is to select a pickup point that will best match the area where you will be dropping the new data. You can adjust the size of the clone tool by selecting a larger or smaller tool from the brush's panel. In order for your modification to blend in, making it virtually invisible, the clone tool is usually feathered. Feathering means that the data picked up by the clone tool is diffused at the edges. You can vary the amount of feathering by adjusting the numerical assignment.

ALL THE NECESSARY ADJUSTMENT FEATURES ARE AT THE TOP OF THE SCREEN.

This is a tricky tool to master. It is also the tool that you will access the most often when correcting your underwater photos. Don't become discouraged—just keep practicing. It will be worth the effort, because you will find that this tool is a life saver!

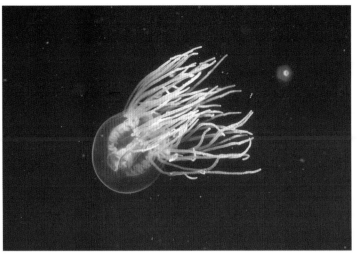

Jellyfish picture taken in Mexico has a small amount of backscatter and a low background density.

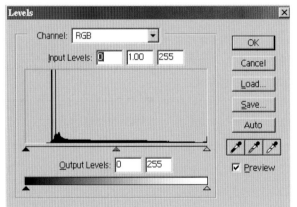

The histogram shows that there is no detail appearing in the shadow end of the image.

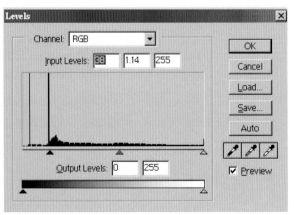

The shadow slider in the histogram is moved over to the edge of the data in the chart. When this is applied, the new data range will be from full black to white.

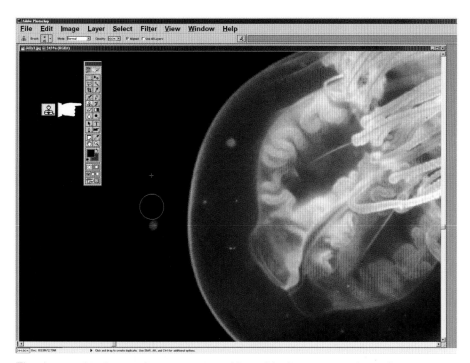

The clone tool is then used to remove any additional backscatter particles in the image.

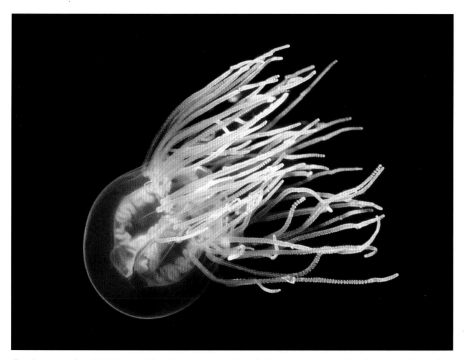

Final image after backscatter has been removed and the gamma range has been readjusted.

Just before the photographer took the picture, a diver swam overhead and knocked debris into the shot. Backscatter was removed with the selection and clone tools. The gamma was altered with the histogram and the face was corrected with the color balance tools.

○ Opacity

One of the clone tool's adjustment features located at the top of your screen is the opacity. When it is set to 100%, all the data is dropped onto the new location. At 50%, half of the selected data is mixed with the area being modified. It is vital to use the opacity when the backscatter is in an area where the background has graduating levels of water color. Even the slightest change in tone is obvious, so be very precise in your pickup selection. If your clone tool shows when you release the data, try again and either select another location to pick up the data or adjust the opacity function.

○ Polygonal Lasso Tool

When you take flash pictures at night underwater, you will find that you have illuminated large quantities of dirt, sediment and itsy, bitsy critters. Because it is dark and your flash's beam doesn't extend far, the resulting photos will have these specks highlighted against a black background. If you select the clone tool to correct these backscatter particles, it will take you forever. Instead, use the polygonal lasso tool or irregular selection tool from the floating toolbox. This will allow you to select large selections of backscatter and make one correction for the entire area.

Before you begin, you should set the background color in the color palette to match the color of the image's background. This is done using the eyedropper tool located on the floating toolbox. Simply take the eyedropper tool and touch a black area

THIS WILL ASSIGN THE FOREGROUND COLOR IN THE PALETTE.

representative of the entire background area. This will assign the foreground color in the palette to match your selected black area. Touch the small arrow between the foreground and background color palette and your selected area toggles to become the new background color.

Take the polygonal lasso tool and select a large are of backscatter located somewhere on the same black area you selected with the eyedropper. Hit the delete key and the selected area is replaced with

the background color, magically removing all the backscatter. If a fine line appears showing where the selection was made, you have two choices. You can then take the clone tool to eliminate the telltale line or undo the entire effect and use a very large clone tool to remove the backscatter.

○ Magic Wand

So far, we have been talking about backscatter particles floating against a black background. Not all underwater pictures have dark backgrounds. If you have exposed your image correctly to include the colors of the sunlit water, you will have photos with backgrounds that have varying degrees of blues and greens. When the backscatter particles are on a colored background, the clone tool will not effectively remove the particles.

This means we have to dig deeper into our bag of digital tricks and select the magic wand from the floating toolbox. This handy tool is designed to pick a group of pixels similar to the one you first touch. You can adjust just how much it picks up by setting the numerical assignment for the tolerance. If the tolerance is set to a low number, it will select only those pixels close in value. Setting it to a larger number will allow you to select a wider range of pixels.

THIS MEANS WE HAVE TO DIG DEEPER INTO OUR BAG OF DIGITAL TRICKS.

Let's say that you have backscatter particles in the blue water around a diver. Use the magic wand

Original color slide taken in very turbid water with heavy backscatter.

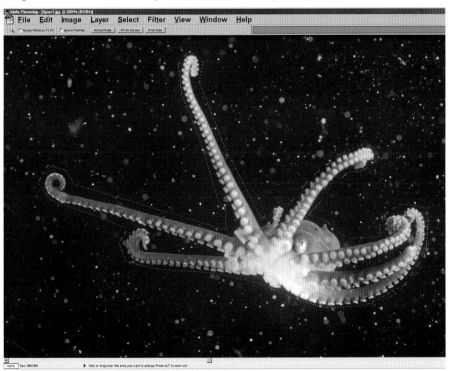

The lasso tool is used to select most of the affected area around the octopus.

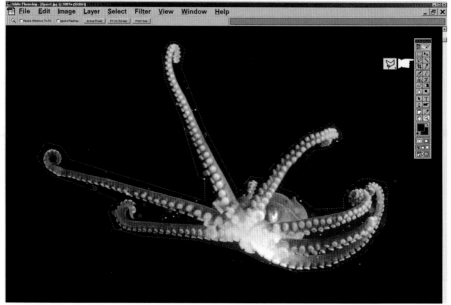

The delete key is then used to remove most of the selected backscatter.

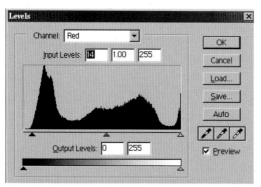

LEFT: The gamma/histogram is then used to reduce the background to a pure black.

BELOW: The clone tool is then used to remove any remaining backscatter particles near the legs and body of the octopus.

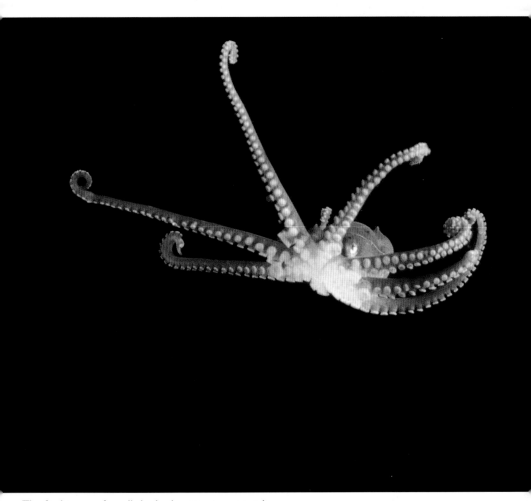

The final image after all the backscatter is removed.

to select the blue water above the diver, then holding down the shift key, add any other blue values around the diver that you need. Once you have selected all the particles, go to the filter pulldown menu and then to the noise menu. This roundabout trip eventually leads you to the dust &

THIS MEANS WE HAVE TO DIG DEEPER INTO OUR BAG OF TRICKS.

scratches filter. When this filter is applied, it looks for dust and small scratches inside the selected area and applies a blur filter to just those specific areas. Since the program really does not know the difference between dust and backscatter it fixes both pests. You can also use the dust & scratches filter with the polygonal lasso tool to remove backscatter inside any selected area.

An alternate method for selecting the blue background is with the color range eyedropper found in the select pulldown. This eyedropper allows you to select a specific color and all the colors similar to it in the photo will also be selected. You can add with the "+ eyedropper" and subtract with the "– eyedropper." When you have completed your final selection, apply the dust & scratches filter and you will have a perfectly salvaged underwater photo.

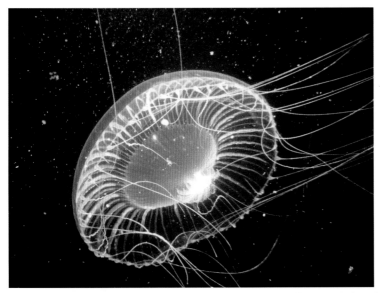

An excellent example of backscatter. Image taken on slide film more than thirty years ago, and saved until technology could fix it.

Most of the area around the jellyfish was selected and deleted. The gamma/histogram was then used to create a black background. Finally, the clone tool was used to remove the last few backscatter particles.

Picture of diver and octopus in the waters of the Pacific Northwest. Notice the backscatter particles around the point where the light exits the flash.

FACING PAGE: The backscatter was removed by selecting the area around the flash head and diffusing it with a blurring filter.

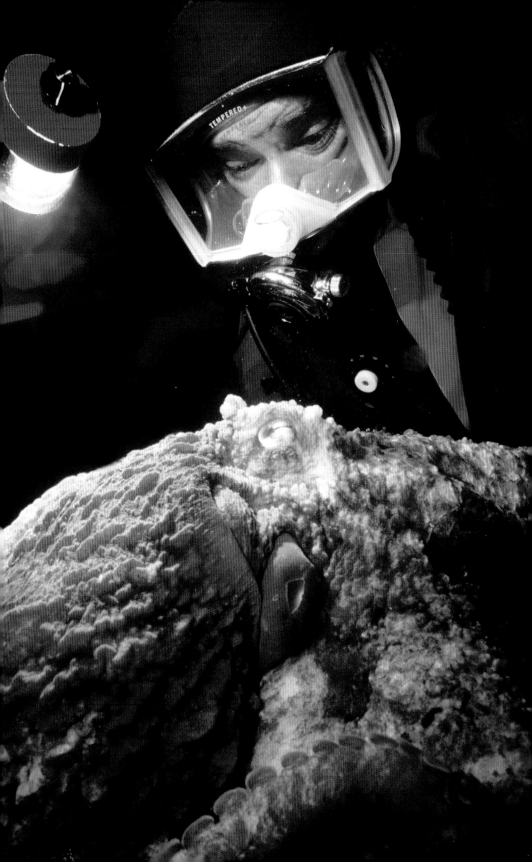

Grain
Reduction

THE BUILDING BLOCKS OF FILM are small particles called silver halide crystals. As color film goes through its transformation from crystal to color dye, these crystals form a very small pattern that creates the detail in the under-water picture. This fine detail is called grain and you can see it when you zoom in tightly on a small section of a photograph. The quality of an image can be reduced if the grain is predominant. Higher ISO films have larger grain patterns than do lower speed films. This is why underwater photographers generally prefer to use low ISO films whenever the lighting conditions allow.

THESE CRYSTALS FORM A VERY SMALL PATTERN THAT CREATES THE DETAIL.

Over the years, film manufacturers have been improving film in an effort to reduce grain. Nevertheless, grain is a trait found in all film emulsions. Digital cameras now offer an advantage because their images are grainless. Since digital cameras are just making their way underwater, we need to find a solution to reduce the grain on film images scanned into the computer.

○ Higher ISO Films

There are several factors that tend to make grain larger than normal. Underwater photographers are in a constant battle to get enough light on a subject. The best solution is to use a larger strobe to better light the scene. If a more powerful strobe isn't an option, then your only other choice is to increase your film speed. In order for the emulsion to capture low light, the silver halide crystals have to be larger. Although the higher film speed offsets the lack of light, the higher ISO films result in increased grain.

THERE ARE SEVERAL FACTORS THAT TEND TO MAKE GRAIN LARGER THAN NORMAL.

○ Depth of Field

When the subject is in focus, the image has no apparent grain structure. As your subject drops to out-of-focus areas, the grain becomes more apparent. When you approach areas that completely lack focus, the apparent grain size reaches its maximum. This is the problem that occurs with underwater close-up pho-

tography, which is extremely popular with all underwater photographers.

○ Blue Layer

Another cause of grain concerns a physical limitation of film itself. The way film is designed causes the blue layer to be inevitably more grainy than the red or green layers. Selecting another brand of film is not the solution, because they all react the same way. This is particularly a problem for underwater photographers since blue is often the predominant color in underwater pictures. This means underwater photographs have more than their fair share of grain problems.

○ Enlargements

No matter just how you got grain, if you are using film for taking underwater pictures then your images are going to contain grain. The problem arises when you decide to make enlargements to

THE PROBLEM ARISES WHEN YOU DECIDE TO MAKE ENLARGEMENTS.

hang on your wall. What may have looked great at 4" x 6" will take on a totally different appearance at 16" x 20". As these images become magnified, the increase in grain structure may become so apparent that it distracts the viewer from the content of the image. The answer to this and other grain problem is to scan the images and go to work editing with your computer.

○ Solutions

Before we had computers we used to tease the new photographer on the block about having a magic grain reducer. Little did we know, that such a magic trick was just around the corner in computer image editing software.

Although 96% of the images taken today are on color negative film, slide film still offers smaller grain. The problem with slides is that they have an extremely narrow tolerance for incorrect exposure. You must have your lighting and underwater situation totally under control when you plan to use slide film. If you are able to obtain good underwater images using slide film, then it is a great method of grain reduction.

SLIDES HAVE AN EXTREMELY NARROW TOLERANCE FOR INCORRECT EXPOSURE.

Digital ICE™

As we mentioned earlier in chapter 3, most film scanners today offer help with grain reduction. Scanners with Digital ICE™ scanning technology automatically offer aid in reducing grain, repairing scratches, dust removal and lost color restoration. Often just running your images through a scanner with this phenomenal technology will solve your problems. For the remaining unsolved problems you will have to try some of these additional solutions.

Color negative damaged during processing. Heavy grain and watermarks that could not be washed off make this image unusable. Or is it?

Comparison images showing how scanners with the Digital ICE™ technology remove some of the problems in the image. The water spots are reduced and the grain structure is more manageable.

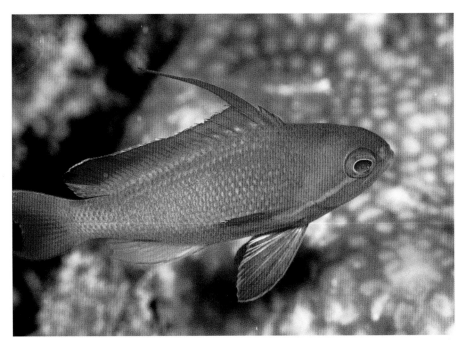

Full frame of damaged image scanned using the Digital ICE™ technology. Minimal work with the clone tool is necessary.

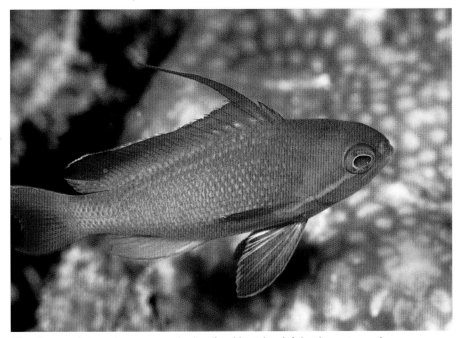

The clone tool is used to remove the last few blemishes left by the watermarks.

Despeckle and Dust & Scratches Filters

If the grain is apparent throughout the entire image, then a treatment to the entire image with a filter is the solution. In Adobe Photoshop, go to the filter pulldown and select the noise panel. From there, you can use either the despeckle or the dust & scratches filters. Both blur the complete image slightly, which eliminates the grain. The despeckle filter looks for image edges and protects them while it slightly

THE DESPECKLE FILTER LOOKS FOR IMAGE EDGES AND PROTECTS THEM.

blurs the small particles that make up an image. The despeckle effect happens immediately when you select it, which amounts to an all-or-nothing fix. The dust & scratches filter has radius and threshold con-

Grain in the overall image can be removed with the despeckle tool. This image is an enlarged section to show both despeckled (right) and undespeckled (left) areas.

trols to fine-tune the effect. The dust & scratches filter also allows you to preview the effect so you can make subtle changes.

A more time-consuming approach is to isolate the more severely grainy areas with the select tool.

The dust & scratches filter can be applied to the selected areas to reduce the appearance of grain. Since only specific out of focus areas were selected, a stronger filter was used to reduce the grain.

A comparison showing the image before and after the use of the select and dust/scratches tools to reduce grain.

Sharpen Filter

Blurring the grain has an effect on image sharpness, but you can gain most of it back using the sharpen filter. Simply go to the filter pulldown and select the sharpen filter. This will not bring the grain back, but will recover some of the sharpness lost with

THIS PROCEDURE IS A QUICK FIX AND WORKS BEST ON HIGH SPEED FILMS.

the dust & scratches or despeckle filters. This is a quick fix and works best on high speed films with heavy grain structure throughout the frame.

Polygonal Lasso

Closeup images and blue water require a different solution that is more time consuming, but provides

better results. First, look over the entire image with a zoom tool and decide which areas need grain reduction and which don't. With macro images you will probably have to use the polygonal lasso tool to manually select those grainy background areas. Make sure that you have the selection tool feathered to a setting of three to start.

THIS WILL REDUCE YOUR SELECTION BY A SPECIFIC NUMBER OF PIXELS.

Go to the select pull-down menu, then to the modify panel and finally to the contract function. This will reduce your selection by a specific number of pixels. Set it to the same number as you used for feathering, which in this case, was three. Apply either the despeckle or the dust & scratches filters to the selected area and your grain will be reduced.

Color Range

If you want to reduce the grain in areas with blue water, you can go to the select pulldown and then to the color range panel. This tool works very much like the magic wand but selects all colors in the image that are similar to the one selected. Use the "+ eyedropper" to select the blue water areas where you want grain reduction. Say OK, and return to the filter pulldown and try either the despeckle or the dust & scratches filters on the selected areas.

Magic Wand

Reducing the grain in just a section of an image requires that you select the affected area. The fastest

tool you can use to make your selection is called the magic wand. You can control just how much area your magic wand selects by varying the setting control from five to fifty. This setting tells the magic wand how many different shades of pixels it should select. A setting of five will select the color you touched and a couple of shades on either side of the selection and fifty will select a wide variety of shades.

If you use the magic wand to select the sky in any image and it also selects other parts of the scene, then you need to lower your selection setting. Reduce the setting until it selects about 50-70% percent of the sky. Using the add selection function, you can then select a slightly lighter or darker area to add to your selection. Eventually all the sky will be selected.

You may find some subjects in an image that have the same color and tone as the sky. If the magic wand accidentally selects these, don't worry because you can easily deselect those portions without starting over. Simply set the magic wand tool to subtraction and manually deselect the area that is not sky. If the area to be selected has many tones similar to those unwanted areas, you may have to use the lasso tool for the entire process.

SOME SUBJECTS IN AN IMAGE MAY HAVE THE SAME COLOR AND TONE AS THE SKY.

10

The Scratch

NO MATTER HOW CAREFUL YOU ARE, there will come a time when your favorite image will become scratched. Of course, it will always happen to the underwater image that was your pride and joy, and never to the mediocre one. To make matters worse, it will inevitably be a photograph from the dive trip where you spent thousands of dollars to travel halfway around the world. The culprit could have been your camera, the film cassette, negative

THERE WILL COME A TIME WHEN YOUR FAVORITE IMAGE WILL BECOME SCRATCHED.

sleeves, slide mounter, or someone carelessly looking at the image on a lightbox. It really doesn't matter how the scratch got there, the hard fact is that *it is there*.

Before digital photography, a scratch was almost a death sentence for an image. Repair was possible, but it was generally beyond what the normal pocketbook could bear. Direct repair on the original film was usually not the answer, so the most common approach was to make a print, retouch it and then make a new copy negative. This required many generations of the image be produced to yield results, so there was quite a quality loss.

○ Digital Repair

With digital software, several tools can be used to repair scratches. Once you get the hang of making digital repairs, you will find your digital darkroom will quickly pays for itself.

When you decide to repair a scratch, scan the image at the highest resolution you can on your scanner. It makes no sense to take the time to repair the scratch on a low resolution file, only

IT MAKES NO SENSE TO REPAIR THE SCRATCH ON A LOW RESOLUTION IMAGE.

to do it again on a high resolution one. Do it once and put the image away.

As we mentioned earlier, most film scanners have the Digital ICE™ technology that helps reduce scratches during the scanning process. It helps, but doesn't always solve all the problems which is why we have included this chapter.

Believe it or not, we couldn't find a really badly scratched photo to illustrate this chapter. We needed a deep, gruesome cut, not a slight wound, so we

inflicted a sad death upon a negative with a sharp razor knife. Ouch! Oh boy did that hurt, but not to worry—we can make it as good as new.

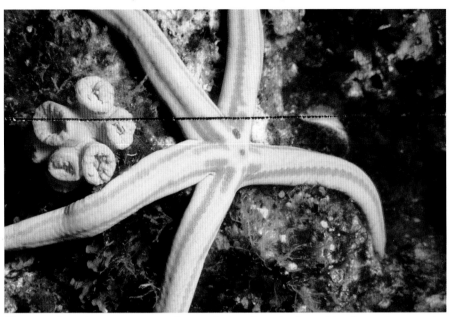

The scratch in this image is very deep and runs through all emulsion layers. It cannot be repaired with the Digital ICE™ technology.

LEFT: The floating toolbox is where we will find all the tools needed to fix the scratch.

ABOVE: Get familiar with the brush pulldown menu. Look at the different shapes and sizes.

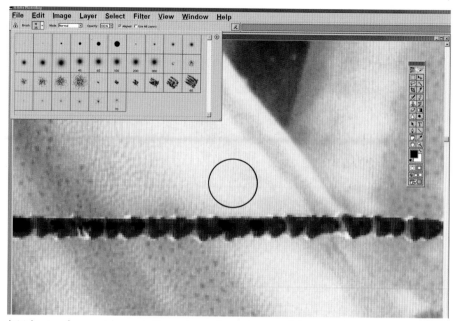

Initial setup for scratch repair. Zoom in on the main part of the scratch and select the clone tool. Set the size slightly larger than the width of the scratch.

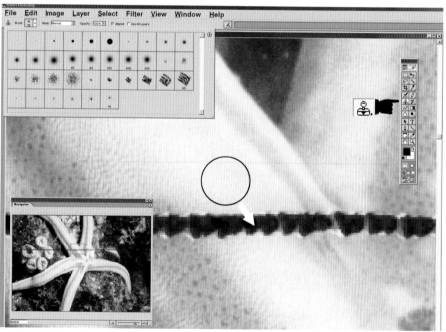

The clone tool is used by selecting areas next to the scratch and dropping them on the scratch. Care must be taken to drag data from similar areas so that the blend is accurate. In this case, we moved data at an angle to the scratch, not parallel to it.

Continue dragging and dropping data along the scratch making sure you are parallel with the flow of the tonal values next to the scratch. If you make a mistake, undo or step backwards, depending on what program you are using.

This expanded view of the drag and drop system shows how you change the direction as the tonal values change in their direction of flow.

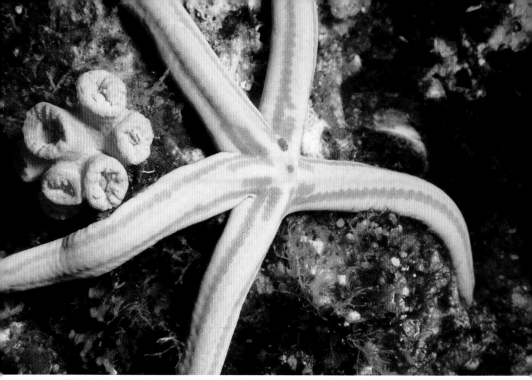

The final image after much work with the clone tool. About fifteen minutes of editing on a good computer was required to make the repair.

Clone Tool

The clone tool is the heart and soul of repair work, so let's put it to work on that nasty scratch. When the image comes up on the screen, zoom in on the areas where the scratch crosses and mentally prepare a game plan on how you should remove the scratch. Usually it will cross a variety of shades and patterns that crisscross the scratch at different angles, so it will need several repair measures.

The clone function is like a miniature image copy tool. Instead of copying an entire image, it replicates a selected area and copies it to another area in the image. To select your pickup point for the clone tool, press the Alt/Opt key and position the circle next to the scratch. Make sure that you follow

the pattern crossing the scratch. Press the left mouse button and that area is immediately copied wherever you repositioned the cursor. In some programs the circle is not visible and the center is indicated with a cross-hair cursor. With other software programs, if you hold down the mouse button, you can drag the selected area and it continuously copies in parallel to the new area, allowing faster scratch editing.

Cloning Tips. Three important techniques for using the clone tool will help improve the quality of your edits. The first is correctly selecting the size of the clone tool. The size of the area to be copied should be about the same size as the width of the scratch. If it is too large, go to the brush's selection and select one size up or down. Be sure not to set your brush too large as it will copy unnecessary data to the new area. This could be a problem if the scratch runs through a sharp line in the image.

THREE TECHNIQUES WILL HELP IMPROVE THE QUALITY OF YOUR EDITS.

The second technique requires that you keep the area to be copied parallel to the tonal values that surround the scratch. If the tonal values run at an angle to the scratch, the clone setup must run at the same angle. Otherwise, you will be copying the wrong color and density onto the scratched area, making your editing visible. It may sound complicated, but as soon as you start editing your first scratch, it will make much more sense. The best part of editing is that if you make a mistake, you can just hit the undo

function. Your incorrect edit is removed and you can start again.

The third technique involves diffusing your clone effect. Feathering makes a much smoother transition, so be sure your clone tool is always in a feathered setting for repair work.

Select a Similar Area

If you are very lucky, the scratch will cross an area with no change in tonal value. In this case, you can use the Select tool and choose a similar area adjacent to the scratch, copy it, place it over the scratch and feather the edges for a perfect match. This technique works best with areas in the sky or dark areas. Even if the scratch crosses several tonal areas, you could use this select method to copy several smaller areas and paste them over the scratch. You could then use the clone tool to finish tweaking those areas that show too much tonal change.

THIS TECHNIQUE WORKS BEST WITH AREAS IN THE SKY OR DARK AREAS.

Sometimes a scratch will cross an area where the eliminated data has no similar counterparts. This is where you get very creative. Zoom the picture out and look around for any pattern or texture that will closely match the missing data. Set the clone tool size fairly small, select some new material and give it a try. If it doesn't work, select the undo and try a different selection. If you find that the clone tool is too strong, you can set the opacity to less than 100%, decreasing the clone tool's effect.

Lasso Your Area

If the scratch comes close to very important data and you don't want to risk using the clone tool, you can use the polygonal lasso tool to mask off your working area. When your clone tool acciden-

USE THE POLYGONAL LASSO TOOL TO MASK OFF YOUR WORKING AREA.

tally moves out of the selected area, nothing happens to the important data.

Your first attempts using the clone tool may be frustrating, but hang in there. This is such a valuable tool, that proficiency is a necessary evil. Even a few hours practice will start you on the road to becoming a cloning pro.

Processing Errors

Nothing is more frustrating than to go on an expensive dive trip and have your images damaged due to a processing error. Often this happens because dive locations do not have all the processing controls found in a regular photo processing lab.

We generally recommend only processing one roll of film on a trip, just to make sure your equipment wasn't damaged in transit. For this chapter, let's

WE GENERALLY RECOMMEND ONLY PROCESSING ONE ROLL OF FILM ON A TRIP.

imagine that your damaged test roll turned out to be the one with the best shots taken on your entire trip. Bummer!

Usually the damaged images will have no blacks, appear flat in color, underexposed, or may even have

color processing streaks. If you're really unlucky, your roll was the one too close to other rolls of film and they stuck together in the film dryer. Most of the errors are due to improper processing times, temperature, or contaminated chemistry. Of course,

RELAX, BECAUSE THERE IS STILL HOPE FOR THESE DAMAGED PHOTOS.

there is always the human factor when it comes to error. Often the person responsible for processing your film is the dive master, who has just come up from a two-tank dive excursion. Relax— there is still hope for these damaged photos. The problem is the fact that there is not just *one* clear-cut solution.

○ Missing Black Detail

Let's tackle one problem at a time, starting with the images lacking black detail. First, go to the image adjust pulldown and try the auto levels function. If it works, then you're done and you can save it as a new file. If it doesn't, undo and go back to the image adjust pulldown. This time, select levels. When the histogram comes up, you should see that there is an open area on the left side indicating that the photographic curve has no blacks. The computer just visually confirmed your assumption. If there is no color shift in this off-black area, then you can move the left slider over to the right until it is under the edge of the data.

Often the black area will also have a red color shift. To correct this, select the red channel at the top

of the histogram menu and move the left slider over to the right until it is under the data. It is also a good idea to check the other color channels to insure that there is no additional data deficiency.

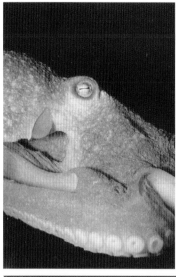

Bad processing caused this image to have no blacks in the shadow area.

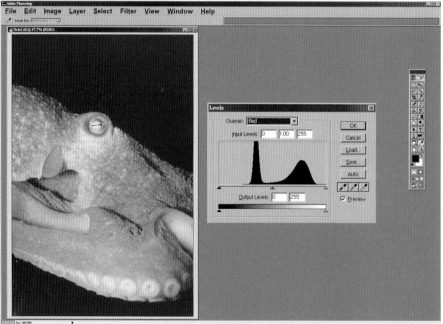

Image with bad processing with histogram chart. Notice that there is no data in the left side of the chart.

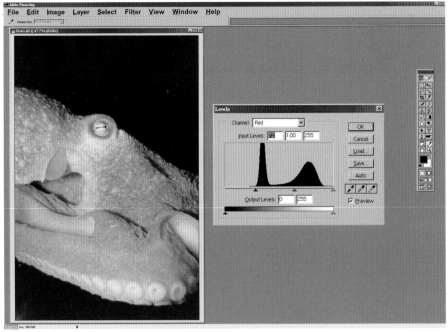

The correction to this image was done with the histogram slider on the left side of the chart. The slider was moved until it was under the leading edge of the data at the left side of the chart. When applied, the entire range of the image was refit so that it had a black DMax level.

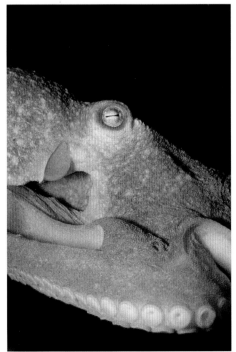

The final correction to the badly processed image now makes it a very useable image.

○ Missing Color

Now let's look at an image lacking color. Try the auto levels function from the image adjust pulldown again. If that doesn't solve the problem, then select undo. Go back to the image adjust menu and try the brightness and contrast panel. Move the contrast slider and view its effect on the image. Frequently, you will also have to adjust the brightness concurrently. That's why they are located in the same menu. If the contrast is all right, but it still lacks color, go back to the image adjust pulldown and select the saturation panel. Increasing the adjustment to this slider will definitely increase the color in the image. One word of warning though, don't overdo the color saturation. Too much saturation adjustment is a sure sign of shoddy photo editing. You may have to compromise on your adjustment so that your editing looks natural.

FREQUENTLY, YOU WILL ALSO HAVE TO ADJUST THE BRIGHTNESS CONCURRENTLY.

○ Underexposed Images

It is often tough getting a good exposure on your underwater images. Conditions like low light, surge, poor visibility and underpowered flashes are just a few of the culprits that make underwater photographers a chosen few. We all look for excuses for our errors and many a diver has blamed the film processor for his or her underexposed images. Before you do, look at the rebate edges on the film. If the film

manufacturer's name and frame numbers look normal but the images don't, then you have a problem with your camera system. If the frame numbers and film name are very dark on slides or faint with color negatives, then you can blame it on the processing.

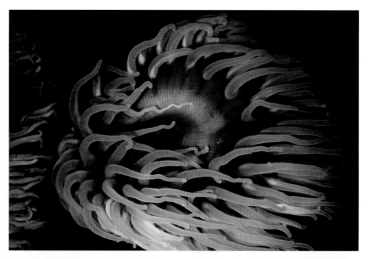

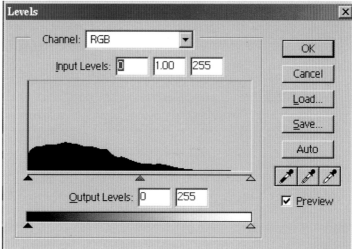

This underexposed image had no whites and lacked detail in the shadows. The histogram showed no data at the highlight end of the chart.

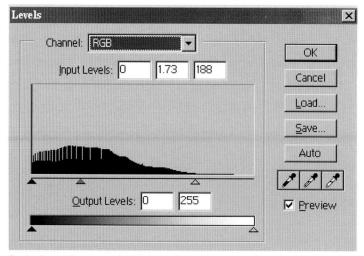

Both the midtone and highlight sliders were moved to the left, which readjusted the image data to the full tonal scale.

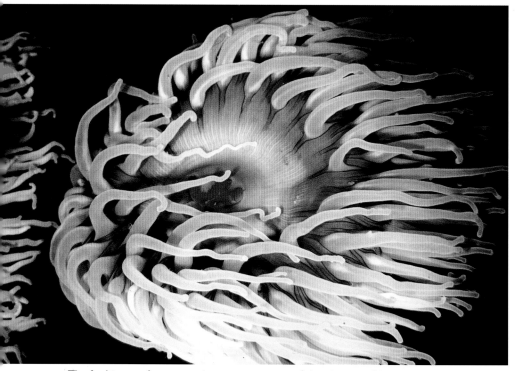

The final image after corrections to upper part of the photographic curve.

Either way, you have an underexposed image that needs some help. Computers can do some incredible things, but they can't bring back to life what doesn't exist. Digital editing can only enhance what has been captured on the emulsion. Salvaging underexposed images is like a juggling act, because every underexposed image requires a different correction. We will offer you the most common solutions and you can take it from there.

As usual, it is prudent to try the auto levels first. The odds are that it will not work, but it's always worth a try. Go next to the variations menu at the bottom of the image adjust pulldown. Look at the lighter/darker part of the ring-a-round and

OFTEN, A COLOR SHIFT IS HIDDEN BENEATH THE UNDEREXPOSURE.

begin increasing the exposure. Often, a color shift is hidden beneath the underexposure and will not show itself until the image is lightened. If there is a color shift, then move to the ring-a-round and correct the color. Don't worry if the image doesn't look

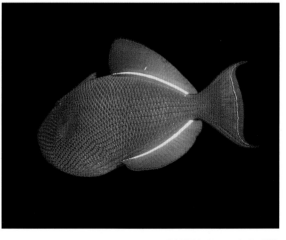

This worst case scenario was salvaged with considerable adjustment to gamma curves via the histogram. The final image was enlarged and cleaned up using the clone tool.

perfect yet, as you still have one additional menu up your sleeve.

Open the levels menu from the image adjust pull-down and look at the right and left edge of the histogram. If there is a gap in the data, move the slider under the edges of the data in the histogram. Analyze the image data between the white and black areas and adjust the midtones with the middle slider.

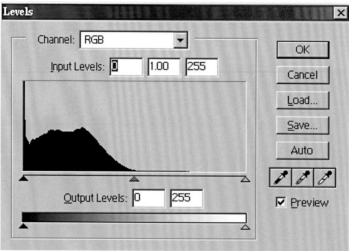

Underexposure of the octopus eye prevented this image from being used for stock sales. The histogram of the image indicated that considerable highlight detail was missing.

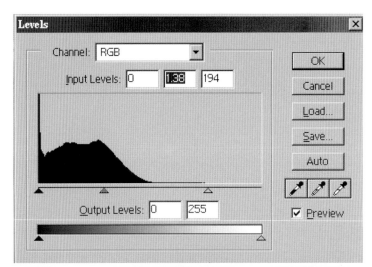

Both the midtone and highlight sliders were moved to the left until the image had a good black to white tonal range.

Moving it to the left lightens the midtones and moving it right darkens the midtones. Keep in mind that you will not be able to correct all of the underexposure, but whatever you do is better than what you had previously.

○ Color Streaks

We are now ready to tackle the most difficult type of processing error you will ever see. Color streaks and chemical spots are caused by contaminated chemistry or when film sticks together during processing. If these streaks or spots are small, then you can treat them as if they were scratches—and you are already adept in scratch repair, right?

WE ARE NOW READY TO TACKLE THE MOST DIFFICULT TYPE OF PROCESSING ERROR.

If the streaks or chemical spots are very large, you might be in trouble. Attempting to fix these errors will definitely sharpen your editing skills. Using either the polygonal lasso or the magic wand, try to select just the area that has the processing problem. With either tool, make sure that you set the feathering to a setting of one or two. Trial and error will determine which setting actually works best.

Go to the layers pulldown, select a new adjustment layer and then move on to levels. You need to just click on the OK and it will automatically name the new layer and apply the defaults. A histogram of the selected area will now appear on the screen. You will now need to play with the midtones of the RGB (red, green and blue) sliders in an attempt to correct

the color error. Try one at a time and view its results before moving on to the next color. When you have exhausted all efforts and error is still visible, it may be because you have overcorrected.

With this new layer, you can make a series of corrections and they will remain a separate layer from the background. You can keep accessing it via the window show layers pulldown. Once you have achieved perfection, then go to the layers pulldown and flatten image to combine all the layers.

To fine-tune your editing, you can also use the clone tool at 100% opacity. This tool allows you to perform a final tweaking to hide any editing signs. Another option is to use the burn and dodge tool from the floating toolbox. These tools will either lighten or darken an area selected in the circular cursor. You can make your selection area smaller or larger by changing brush size.

THIS TOOL ALLOWS YOU TO PERFORM A FINAL TWEAKING TO HIDE ANY EDITING SIGNS.

When all else fails, you can try using the clone tool again and set it to less than 50% opacity. It will be a slow process, but you can recreate the damaged area using partially cloned information. No one said this was going to be easy!

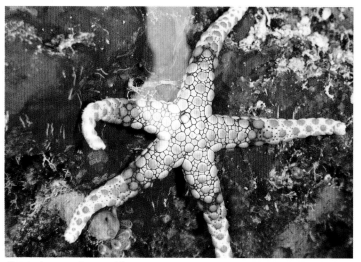

Original image damaged by processing stains.

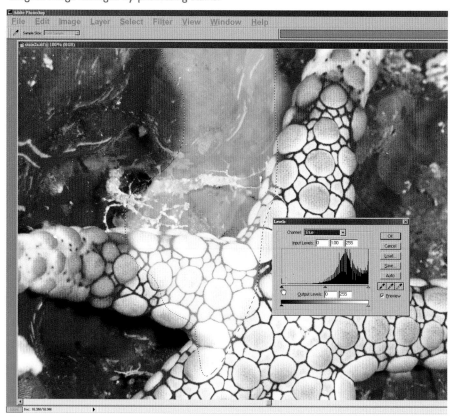

The stained area was selected using the magic wand.

When the histogram is opened, the data display only refers to the selected area. Each color channel was selected and modified with the sliders until the stain slowly disappeared (above and left). The completed image appears below.

Ethics of Photo Manipulation

THE EVOLUTION OF DIVING has changed the way we look at the ocean environment. Instead of shooting animals with a speargun, we now use a camera. This new environmental awareness has even changed the way we interact with the reef when diving or taking pictures. We now make a concerned effort not to touch the reef with our hands or any other parts of our dive equipment.

> ENVIRONMENTAL AWARENESS HAS CHANGED THE WAY WE INTERACT WITH THE REEF.

This presents us with a dilemma. Since many of the underwater pictures taken years ago show hands or dive equipment touching the reef, what should we do with these photos? They are no longer politically correct and don't set a good example for divers

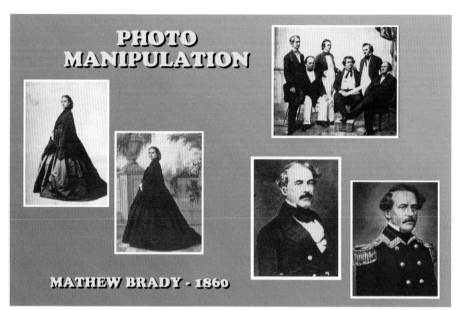

PHOTO MANIPULATION

MATHEW BRADY - 1860

The digital world is blamed for much of the photo manipulation we see today. The truth is that Mathew Brady and other well-known photographers were manipulating their photography as early as 1860.

being introduced to the ocean. Do we just put those pictures away, never to be used again? Or do we contend that they illustrate the way it used to be? The easiest way would be just not using any of those images, but many are irreplaceable. Should we use photo editing software to change the pictures so they are acceptable, or do we just leave them alone?

Now the question of ethics comes to the surface. When is a picture manipulated and when is it enhanced? Is it ethical to do either one? This question has brought about much argument in the last few years, and the problem is not going away any time soon. Unfortunately, there is no standard answer to these questions, and everyone has to

WHEN IS A PICTURE MANIPULATED AND WHEN IS IT ENHANCED?

decide their own beliefs. We have done considerable research on the subject, and think we at least have some definitions that may help.

○ Enhancement vs. Manipulation

Photo Enhancement

Images converted to digital files and altered using techniques similar to those used by traditional photo labs are considered enhanced photos. Images in a traditional lab are corrected for color balance, exposure, focus, cropping and finished color prints are even spotted. Using computer software, the same functions can be accomplished using color correction, the brightness adjustment, cropping tool, sharpening filter and even dust and backscatter can be removed with the clone tool.

USING COMPUTER SOFTWARE, THE SAME FUNCTIONS CAN BE ACCOMPLISHED.

Photo Manipulation

When new images are created using parts selected and pasted from other photos, the new photo is considered manipulated. If you selected several fish from one photo and pasted them into another image that had a better background, it would be considered a manipulated photo. If you add additional fish to a school, or add a silhouetted diver to a scene, then it is regarded as manipulated. Two whales breaching simultaneously, or a dolphin jumping silhouetted by a sunset are a couple of manipulated images we have seen in the last few years. Photo

manipulation also applies if areas in a photo are deleted in an attempt to improve the image. Because you can't always see edge to edge in the viewfinder, you occasionally miss the critter's tail. Removing him is deemed manipulation.

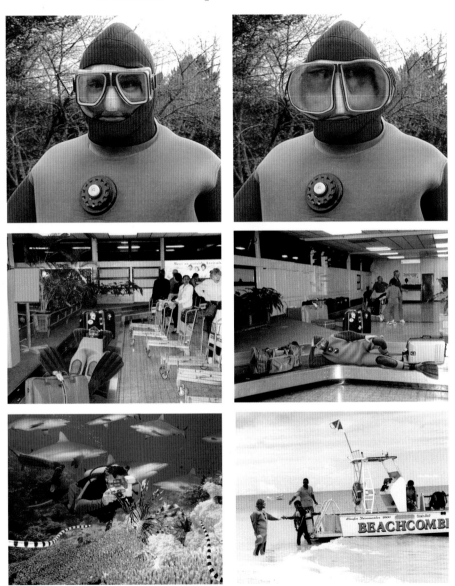

This series of manipulated images was created for a satirical slide show presented at a variety of underwater film festivals. The digital world made it all possible.

○ Do You or Don't You?

Each person must make their own decision whether to cross the line between using enhanced and manipulated images. It is not an easy decision to make. Much depends on why you take underwater images and just how you use them. Before you decide, remember that once you manipulate and create an almost impossible image, you set a standard for yourself that will be impossible to change. When you truly take a photograph that looks too good to be true, there will always be that sliver of doubt in the viewer's minds. If you can live with that, then the decision should be easy.

MUCH DEPENDS ON WHY YOU TAKE UNDERWATER IMAGES AND HOW YOU USE THEM.

○ Do We or Don't We?

We could end the discussion here, but we think it only fair that you understand how we approach this problem. We feel we have achieved a good compromise that may help you with your ethics decision.

As photojournalists, we write regularly for at least seven magazines. Since we use photos to illustrate what we write, we do not manipulate images that would depict a scene in an unnatural way. We *do* utilize all the traditional corrections mentioned in our definition of enhanced photography. Most

FACING PAGE: Digital manipulation with 3-D programs can create some unusual effects, such as this image of the Nai'a in Fiji. The program used to create this image is called Bryce.

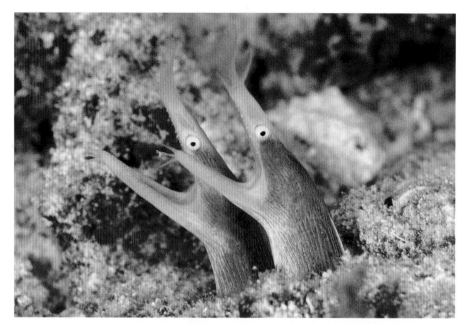

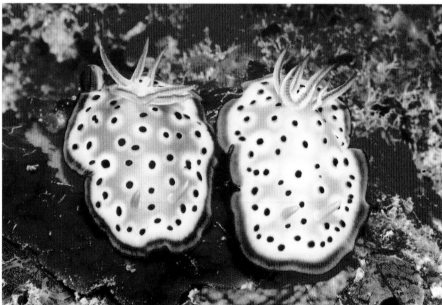

The downside to digital manipulation is that when you take some really nice underwater images, viewers may doubt that they are real. For example, when you find two identical animals underwater, everyone thinks you cloned one next to the other. In the case of these images (above and facing page), they are real, with no computer manipulation other than color correction.

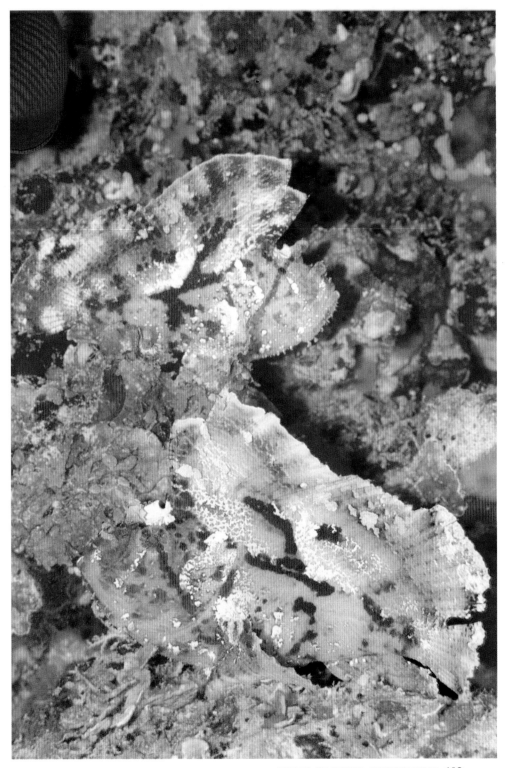

scanned images need dust spotting and a slight color correction. If we have images with hands or gauges touching the reef, we look for other images. We do not add fish or any other object that wasn't in the original photo. We may however delete items we feel detract from the composition of an image. In a nutshell, any image we classify as necessary for journalistic content, we leave alone.

WE DO NOT ADD FISH OR ANY OTHER OBJECT THAT WASN'T IN THE ORIGINAL.

This doesn't mean that we don't manipulate images at all. Any illustration representing a visual concept is fair game for any type of image manipulation. We are occasionally asked to design covers using some of the software programs we test. Often we take the images representing the real world and manipulate them to a point often called bizarre. In our efforts to produce video presentations for underwater film festivals around the world, we sometimes take visuals one step further. Several of our programs are humorous and require image manipulation to create the punch line.

On extremely rare instances we find it necessary to use a photo that is unique and politically incorrect. If we have no other choice, we then make the least amount of changes necessary for publication. As you can see, there is no well-defined line for ethics in our new underwater photo world.

In the publishing field, there is a standard symbol (©) to indicate that a photo has been copyrighted. There is a movement in the publication industry to

establish that a symbol be required on all manipulat-
ed photos. Although no symbol has been decided
upon, a suggestion has
been made for a circle
surrounding the letter M.
Until a standard has been
established, we will all need to rely upon our own
code of ethics.

WE WILL ALL NEED TO RELY UPON OUR OWN CODE OF ETHICS.

Silver Pixels

U NDERWATER PHOTOGRAPHERS ARE NOTORIOUS for setting up their own unique methods for obtaining great underwater images. Each of us thinks that we have the best solution for creating underwater masterpiece images. Some photographers use slide film while others select color negative film. One diver uses a certain brand flash unit and a dive buddy swears by another. The only commonality

EACH OF US THINKS THAT WE HAVE THE BEST SOLUTION.

among them all is a love of the sport and a firm desire to record it for others to appreciate.

How many times have you decided not to take a picture because you knew the backscatter in the water would make the image unusable? You proba-

bly didn't bother taking a photo of a manta cruising by because it was too far away for your flash to properly light, right?

Well thanks to the digital darkroom, problem underwater photos can now be corrected. So, maybe underwater photographers need to rethink their photo techniques a bit. Knowing that your computer system can help save the day, you might start thinking of the film in your camera as a chemical storage device. You need not miss photo opportunities again. Backscatter be damned! Bring on those rare critters and unique shooting situations. Go ahead and take those pictures—you can fix them later. Let's take a look at a few tricks underwater photographers can perform with the aid of a computer and photo editing software.

MAYBE UNDERWATER PHOTOGRAPHERS NEED TO RETHINK THEIR TECHNIQUES.

○ Fishy Pictures

Every underwater photographer wants to take pictures of fish. They come in all shapes and sizes and are so colorful. Even non-divers can easily recognize them in photos. The problem is that these fish are elusive. Rarely will one come close enough to the diver to enable a great close-up shot. Instead, you have to resort to a medium telephoto lens, often used with a housed land camera. To get good exposures, you must use wide apertures or large, expensive electronic flashes. Even when you do use flash, the background appears black due to light fall off.

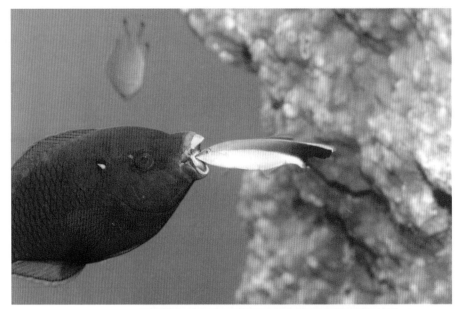

THIS PAGE and FACING PAGE: Shot with an underwater housing on high speed color negative film.

Images were scanned and then edited for color balance and exposure. Grain reduction was then applied to the final image.

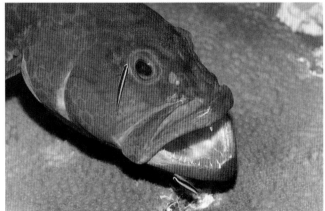

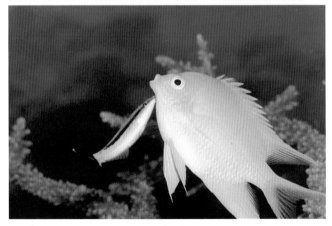

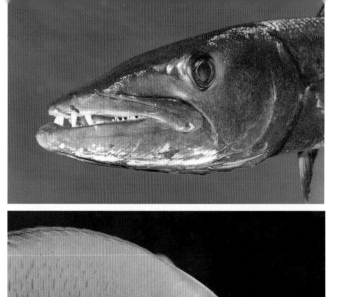

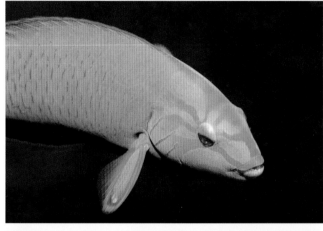

One solution is to use high speed color negative film. It allows you to use smaller apertures which provide plenty of depth of field. Since it has a higher film speed, it also allows you to use a smaller flash. This saves you some money and permits you to streamline your underwater photo gear. On the flip side, the grain is considerably larger. Not to worry because you can now reduce the grain for the entire image, or just select the specific area. The methods used to reduce grain should be fresh in your mind, because we just discussed them in chapter 9.

○ Fluorescence Photography

Since they first took cameras underwater, photographers have attempted to capture the fluorescence of certain sea anemones and corals. These animals

Creating fluorescent pictures is now easy with the use of high speed color negative film and the auto balancing feature in software programs.

ABOVE: Original photograph. RIGHT: Touch a white object in the scene with the white eyedropper and you have a perfect fluorescent picture.

emit a low light fluorescence output that is only captured when ultraviolet light reflects off them. Photographers have tried special filters, unique strobe systems and have even employed underwater tripods to capture this effect on film. Very few attempts have proved successful.

Today there are several special high speed color negative films that have a fourth layer that works

well to capture fluorescence lighting. You don't need special filters, flashes or any special equipment to get the photo. Just use the available light in the scene to record the fluorescence.

Take the processed color negatives and scan them into the computer. They will have a heavy bluish cast and appear very flat in color. If you go the image adjust pulldown and then to the levels editor, you will be presented with a histogram of the image. Take a quick look at the entire scene to see if you can find a small piece of coral or any white object.

THEY WILL HAVE A HEAVY BLUISH CAST AND APPEAR VERY FLAT IN COLOR.

Touch that object with the white eyedropper and the entire scene will rebalance to a normal color range. You will see that some fluorescence is beginning to appear. We still need to enhance it more, so go to the saturation panel in the image adjust pulldown. Increase the saturation until the fluorescence is fully visible.

If you cannot find an object in the scene that has a white density, you will have to go to the image adjust variations ring-a-round and adjust the color and exposure. You will notice at the upper portion of the screen there is a fine coarse adjustment. You should set it to coarse in order to see the change in the ring-a-round images.

○ Extreme Macro

Macro photography is one of the more popular types of underwater photography. Unlike fish, the

With high resolution film, you can use your computer and image editing software to enlarge an existing macro photo to simulate higher magnification.

animals you record are fairly stationary. This makes it a bit easier to accomplish, except that most critters are rather small. This means that you have to move your flash in pretty close to light the subject. When you get to a 1:1 reproduction ratio and even higher magnifications, your camera lens is almost directly on top of the subject. Worse yet, you still have to get a flash in there to light the subject, which makes extreme macro photography very difficult. That's a shame because some of the most interesting creatures are found at these extreme magnifications.

Using the computer and editing software, you take an existing macro photo and enlarge it to simulate higher magnification. Because magnification increases the visibility of grain, you will need to take

the original photo on a high resolution, fine grain film, usually ISO 100 or less in speed. Color slide films work the best as their grain structure and sharpness is superb at these high magnifications.

Let's assume that you have taken some great macro photos on fine grain slide film. Scan the images in at your scanner's highest magnification. Using the crop tool found in the floating toolbox, select the section of the image you want to magnify. Go to the filter sharpen pulldown menu and select the sharpen more filter and apply it to the image. The fine grain of the slide film will not increase much using this filter, and you can now attain 4:1 and 8:1 image magnifications never before possible.

Because magnification increases the visibility of grain, you will need to take the original photo on a high resolution, fine grain film—usually ISO 100 or less.

Photo Stitching

PANORAMA PICTURES ARE NOT SOME NEW FAD. They've been around for ages. Photographers have been employing the cut and paste panorama method since the beginning of photography. You know—the ones where prints from various negatives were mounted together to form one single montage image. Sure, it gave the correct panorama impact, but let's face it, the edges between each print showed and looked rather shoddy.

THE EDGES BETWEEN EACH PRINT SHOWED AND LOOKED RATHER SHODDY.

One of the spin-off technologies of space research is called photo stitching. The spacecraft on Mars could only shoot sections of a picture and transmit the parts back to Earth. The images were

then run through a computer program and compiled into one wide format image of the Martian landscape. This technology is now available to consumers as specific panorama software or through the photo stitching tools supplied with most image editing software.

○ Photographing the Parts

To see just how the program works, we need to start by photographing the pan parts. The best way is to have your camera on a tripod, preferably one with a pan head and bubble level. The idea is to take multiple pictures as the camera pivots around its focal point. Make sure the tripod and camera are level with the horizon. You can try hand holding the camera, but you must keep the horizon level or distortion will occur. Correct vertical camera orientation minimizes this distortion in the overlap areas.

MAKE SURE THE TRIPOD AND CAMERA ARE LEVEL WITH THE HORIZON.

Autofocus can be used if there are no close objects that would drastically alter the focus. You'll have better luck in your final image assembly if you leave plenty of sky and foreground. Keep your lens zoomed identically for all photos in the panorama. Each image should have about 25% overlap of data for best results. The wider the lens angle, the more you will need to overlap to compensate for lens distortion.

Since you will be making as much as a 360° rotation while exposing your images, there could be vari-

Underwater panoramic scenes are photographed with overlapping parts to be assembled later.

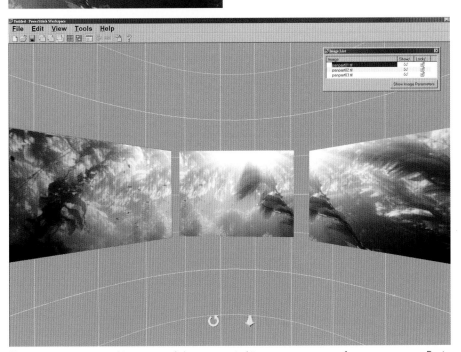

Pan parts are imported into one of the many stitching or panorama software programs. Basic alignment is set up.

The program is then given the command to align the parts. The program will analyze edges and similar image parts in adjoining photos.

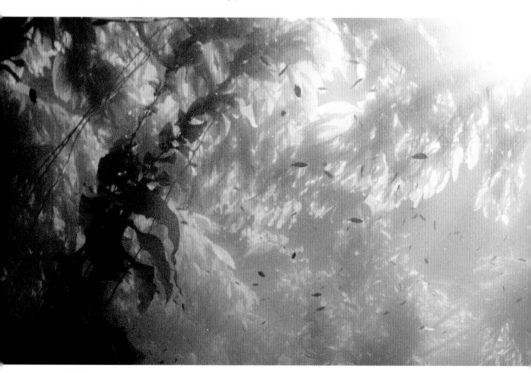

ations in color balance and image exposure. You will probably get the best results if you disable the auto exposure while making your swing. If you have variations in exposure from one picture to the next, it can produce visible seams.

○ What Images Make a Good Panorama?

Images used to make panorama in these photo stitching programs can come from a variety of sources. If you take a camera on your dive trip, you can take several frames showing the resort area. If you find a really nice panoramic underwater scene, you can pan the scene with your underwater camera

Once the alignment is complete, the program will then blend each part with the next. Information about the camera lens is used to minimize distortion of the final image.

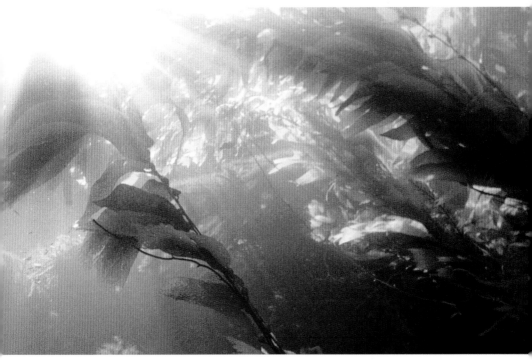

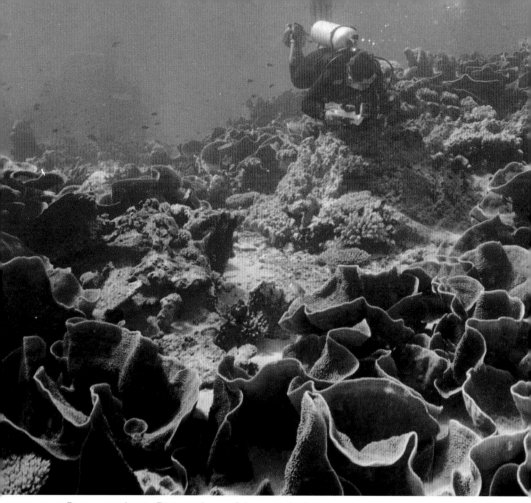

Panorama taken in Fiji is made up of three stitched pan parts.

and create a full 360° pan of the scene. There is even a program that can take video footage and convert it into one panoramic still image.

○ Questions

When you bring your images into the stitching software, you will be asked several questions. What focal length lens did you use? Is the final image going to be a full 360° or a wide format image? Do you want to blend the images? Do you want to warp the images? (Warping takes the focal of the lens used

and bends the edges of each part until they match
the next.) After you have answered all the questions,
the program will take that information and create an
image only possible before with expensive panoram-
ic cameras. If for any reason the parts don't match
exactly, most stitching programs allow you to manu-
ally align the parts. They are then stiched automati-
cally by the software.

○ Film vs. Digital

Both film and digital cameras work well for panora-
mas, but digital has a time-saving advantage, since all

of the images import directly into the program. Because it takes several images to construct the panorama, digital also saves on film usage. Film currently has an advantage since it provides a higher resolution output. With film, you have to scan each part, edit them and then save each as a new

TURN OFF ALL THE AUTO EXPOSURE AND COLOR MANAGEMENT SOFTWARE.

file. It is important that when you scan pan parts that you let the scanner set up the first image. Be sure to turn off all the auto exposure and color management software for the remaining images.

When digital stitching programs first appeared, we started to shoot pan parts whenever possible. While on magazine assignments around the globe,

we continually added pan parts to our stock files. We knew that we could stitch them together later and achieve a wider angle, higher resolution image. Photo stitching allows us to take a whole different look at the world around us, above and below the waterline.

Topside panoramas are a great way to document your dive trip.

Virtual Reality

IN EARLY 2000, NASA SENT UP A SHUTTLE to remap the entire Earth and create Digital Elevation Maps (DEM). You are probably scratching your head wondering just what this has to do with underwater photography. Believe it or not, much of the technol-

IN EARLY 2000, NASA SENT UP A SHUTTLE TO REMAP THE ENTIRE EARTH.

ogy used in underwater exploration comes from "spin-off" technology from space exploration. Often, it comes in the form of software and hardware that share applications useful to underwater research.

As software reviewers for several photography magazines, we recently ran across software programs that could convert 2-D into 3-D using grayscale mapping. It looks at a photo and assigns heights

according to brightness density. We decided to try to use a combination of the Digital Elevation Maps and these software programs to give our underwater pictures a new dimension. After all, the surface of small underwater animals, like the skin of starfish, sea cucumbers and coral all resembled land masses on Earth—or do they?

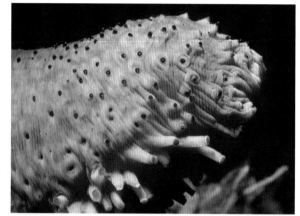

RIGHT: Normal image of a sea cucumber.

BELOW: Surface of sea cucumber is remapped into 3-D and viewed from an extreme side angle.

Some of this 3-D software works in four dimensions that include the X and Y axes associated with 2-D images, Z for depth into the scene, and a time line that allows objects to move about at certain intervals. Most of this software is new to the underwater

world and just getting its feet wet as this book is being published.

Using this software, we can convert 35mm two dimensional images into 3-D digital files that can be rotated and viewed from any angle. As an example, we took a photo of a brain coral and imported it into a software program and converted it to a 3-D object. We were then able to look down the side of the coral, as it took on the look of a mountain range. This provided a photo with depth of field beyond the scope of photographic physics. Wow!

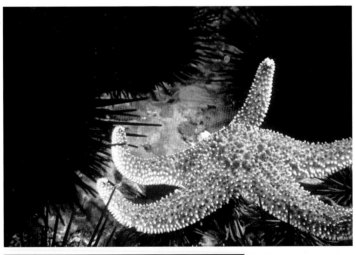

ABOVE: Normal image of a Piaster starfish.

LEFT: Screen capture of 3-D mapping screen used to create these images.

ABOVE: Surface
of starfish was
remapped into 3-D.
The viewing camera
can be rotated to
some extreme views
that are then ren-
dered as new
images.

LEFT: The surface of
each animal was
converted into a
new 3-D
macroscape.

The software has the versatility to add water visibility, control the angle of the light or its falloff and output extremely high resolution images. Because it works in the fourth dimension of time, if you take a camera through a scene, you can also create an underwater movie. We decided to test it out, so we created a short clip where we flew toward the brain coral, turned 90° and coasted down one ridge formed by the coral. What a ride! You can also break the movie down into individual sequential frames so they can be used for slide projection.

We use these software programs for digital slide shows, special effect images, magazine covers and any type of image that needs a 3-D approach. We can create a 3-D file where we place objects such as spheres, sky, sun, moon, mountains, fog, haze, or water. Three-dimensional objects such as divers,

You can mix both 2-D and 3-D images in most 3-D modeling programs. These program react much like the real world with shadows and reflections.

boats, fish, coral, submarines and other assorted underwater objects can then be imported. Best of all, we can also import masked two dimensional objects and place them in the scene right next to the 3-D objects. When all the objects are in place you can then pan around the scene, move through it, above it and under it. To add realism, the water in these programs works like the ocean with filtered light, density, limited visibility and surface wave action.

Don't get us wrong. These images are not meant to replace real 2-D underwater images. They are merely a creative method of incorporating your 2-D images in an artform. Your creative possibilities with this software are only limited by your imagination.

This series of images were created with a 2-D image of DEMA's Reaching Out Award and 3-D models. The award was set in the water and the camera was moved from above to below the surface in a three-image sequence.

Presentation Images

IF YOU HAVE EVER BEEN CALLED UPON to make a presentation of underwater images to a dive club or local group, you know good visuals can make all the difference. Fortunately, there are several software programs today that can help ease the pain of speaking before a group. With all this new technology, some presenters have migrated from slide projectors to computer-driven shows.

NO MATTER WHAT YOU NEED, THERE IS A SOFTWARE PROGRAM TO HELP.

Often, all you need to steal the show are a few fancy title slides. Other times you might need some special effect visuals to give your show some pizazz. No matter what you need, there is a software program to help.

Thousands of underwater clipart images are available to spice up your presentation.

○ Adobe Photoshop

Adobe Photoshop is best designed to make individual text slides rather than an entire presentation. You will find the Type tool in the floating toolbox. When you select this tool, a small menu comes up that allows you to select the typeface, size, color and justification of the text. You just type your text on the screen and if you don't like the way it looks, simply modify the settings.

Since the text becomes a layer, you can modify it any time. If you later decide to move or edit the text, just right click on the text, edit it, add drop shadows, add a photo background, add a glow and even bevel the edges. If you want to move the text, select the text by right clicking on it and move it anywhere using the Move tool from the floating toolbox.

Slide presentation image created with two scanned images, text and red borders. All objects were set as layers in the image until the final position was determined.

○ Microsoft PowerPoint

There are many software programs dedicated to helping you make presentation slides. The program we feel dominates the industry is PowerPoint by Microsoft. This powerful program has a wide selection of preset backgrounds from which to select. If you would rather, you can design your own background that includes a logo or even an underwater photo. If you have quite a few text slides to design, it is best to use the outline mode. This allows you to enter the text for the entire presentation and then fine-tune each individual image.

If you plan to include digitized underwater photos in your presentations, you will need to re-scale them so they are only 1–2MB in size. A good image size to target for is 1024 x 768 pixels. When you re-

scale any image, it is like running a blur filter on the image, so you must counteract this effect by using the sharpen tool.

Lecture images on the use of Nikonos framers were created with one underwater image of a sponge and a studio shot of the Nikonos camera system. The Nikonos was set as an object layer and moved to different positions. Each position was saved as a new file.

With its many formats and presentation abilities, Microsoft PowerPoint is one of the most popular presentation programs. You can create presentations with text, pictures, sound and even motion.

Organizing your presentation is a matter of laying your images out on the software lightbox, or scanning through the basic outline attached to them.

The slide transition function allows you to assign special effects that blend from one image to the next.

LEFT: The mouse menu selects the type of pointer and how it will work during the presentation.

ABOVE: PowerPoint has a slidemeter that tells you if you are going too fast or slow based on the information in each image.

As you compile your computer presentation, make sure you understand which file formats work the best in each program. Although JPEG compression reduces file size, images do take time to uncompress before being previewed. You don't want to wait forever for the files to open, so we recommend TIFF files for use in presentation graphics.

○ Film Recorder Output

Once you design your text slides, you need to decide what type of equipment you will using for your presentation to your dive club. If you will be showing your talk on slide projectors, then you will need to output slides and this requires a film recorder. Instead of the final information being output to a

YOU WILL NEED TO CONTACT YOUR SERVICE BUREAU AHEAD OF TIME.

printer, the data is transferred to a machine that exposes it onto 35mm film. Once completed, the 35mm slide film is processed and then you have finished slides to include in your presentation. Film recorders are rather expensive. If you don't require slides often, you might be better off using a service bureau for output. You will need to contact your service bureau ahead of time, to make sure that you prepare your files to match their machine.

○ Add Video

If you will be using a computer-driven presentation, you have the option of including sections of video. Most presentation programs allow the use of video

clips, but a few things have to be considered ahead of time. Since they require extensive memory and speed to maximize reso-lution, you should scale the videos down in size. An MPEG format at 352 x

240 pixels is a good size for presentations. Most video editing programs have a function that allows you to easily reduce the size of a video clip.

When you combine all your special effects, titles, composite images, still images and video clips you will have a very impressive program to present to your local dive club.

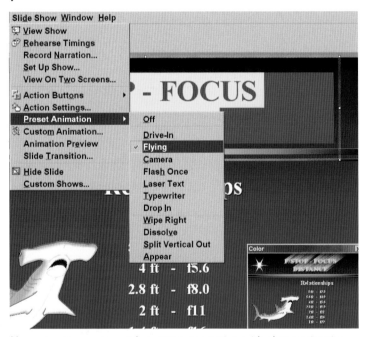

You can spice up your underwater presentation with clever animation—making a fish swim by your text or a bubble come up from the bottom of the screen.

Let's Make a Poster

WE HAVE BEEN DIVING in many locations through-out our underwater careers, but much of our work has been done in the prolific waters of Fiji. During several of our Fijian stays, we had the good fortune of diving aboard an exquisite lady of the sea called the Nai'a. This 120' boat is owned by Todd Barrell and his sister Alexx Edwards and they made our stays aboard a luxury. To thank them for our diving fun, we designed a poster featuring some underwater pictures we took on these trips.

WE DESIGNED A POSTER FEATURING SOME PICTURES WE TOOK ON THESE TRIPS.

The waters of Fiji presented such great photo opportunities, what should be the topic of our poster? After looking through our photos, we found

an abundance of images of underwater nudibranchs. Not to worry, because these sea slugs are much more vibrant in color than their land counterparts. Thus, our poster of nudibranch pictures was aptly dubbed the Nai'a Nudis.

○ Getting Started

It is simple to make a composite poster using your underwater images as overlay images. Decide what size your final poster will be and set those dimensions in the Image Size set up. It will also ask you

IT IS SIMPLE TO MAKE A COMPOSITE POSTER USING YOUR UNDERWATER IMAGES.

what resolution you desire. Set it as close to 300 dpi as possible, depending on how much RAM you have. Remember that each layer you add will increase your file size. We set our background to black so that it would be easy to add and position images. The

Images are dragged from a photo database album onto the Photoshop work area.

background could just as easily have been an under-water image instead.

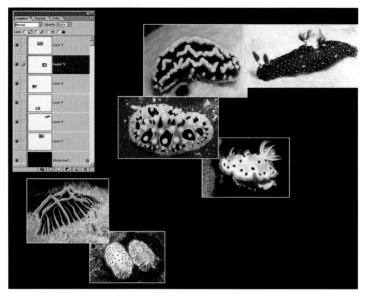

Each pasted image is set as a layer that can be sized and moved on the base image.

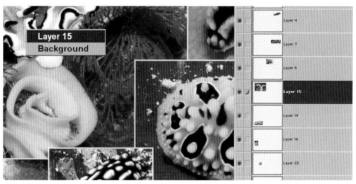

The layers menu gives you direct access to the list of layers in any single background image.

○ Adding Images

Now open the image files that you want to include in your poster. When the file opens, drag and drop a copy of the image onto the background and then close the original image. You can size the copy by

going to the edit pulldown and then to the transform menu. From there you can scale, rotate, skew, or flip the layered image. If you want to see all the layers, go the window pulldown. From there you can see a list of the layers when you select show layers. Each layer can be selected by right clicking on the image.

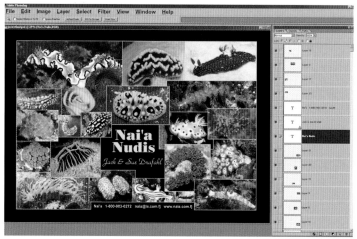

For manipulation, the various layers can be accessed directly from the work area or from the layers menu on the side. The order of the layers can be changed by moving the images up and down the layers menu.

○ Layer Styles

It is best if you add a colored border, drop shadow or bevel to each layer so it separates from the other layers. To add a border, go to the layer pulldown, use the layer style selection, select stroke and you can set the width and color of the border. You can put a colored border around each layer, with a thickness up to sixteen pixels. If you want to add this border to all the layers, just use the window show layers and drag the stroke from layer to layer until they all have a border.

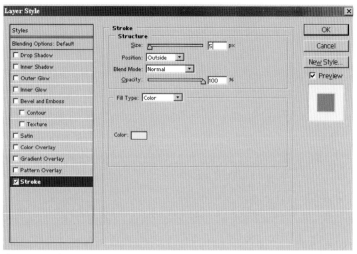

A variety of special styles can be applied to each layer and then copied to other layers. Drop shadows, bevels and borders are just a few of the effects that can be added to each layer.

If you want to give your poster a title, grab the text tool. Set the font size, typeface choice, attributes and color. Place your cursor where you desire the text and type away. If you don't like the positioning, just grab the text and move it to where you like.

○ Saving the File

When you are pleased with your final poster, you need to save it for output. First save the master file in a directory. This will enable you to go back to any of the images and rearrange them later if you aren't happy with the final output. Then go to the layer pulldown and flatten image. This makes all the layers merge into one final file. You cannot access any of the individual images or make any changes. See why we had you save the master first? The advantage to the flattened file is that it is easier to print.

○ Poster Output

Speaking of printing, you can now output your flat-tened file to your inkjet or dye sublimation printer. If you want to output a size that exceeds your printer's capability, you can take your file to a service bureau and use their large output printers. If you require large quantities of your posters, you can also take your file to an offset print house. You will incur some expenses getting the file ready for offset printing, but the more you print, the cheaper it gets. We print-ed a test run of one hundred copies of the Nai'a Nudis on our large inkjet printer. The response to the poster was great, so we had thousands of them print-ed at a local offset print house.

The final poster of the Nai'a Nudis was saved as an 80MB file and sent to an offset printer. The printed posters were later handed out as a promotion at dive conventions.

Digital Slide Shows

FOR DECADES, THE MOST POPULAR method for present-ing underwater images was the slide projector. Single projector shows were used for lectures and viewing dive trip vacation slides, while the multi-projector format was reserved for the profes-sional underwater film festivals. Many of these

SINGLE PROJECTORS WERE USED FOR LECTURES AND VIEWING DIVE TRIP SLIDES.

extravaganzas included programmed dissolving images, special effects and soundtracks that rivaled video productions.

Just like the eight-track tape, 8mm movies, type-writers and records, the slide projector is slowly being replaced. It is not going to happen overnight, but there is a new trend in the works. We call the

new method digital slide shows, but they are actually video editing programs. With these programs you actually create a video presentation, even if you only include still images. This new digital slide show technology is a combination of computer hardware and software that provides underwater photographers creative potential never before possible.

○ Software Programs

More than a dozen programs come under the guise of digital video editing programs. The programs' names may sound like they are only for video producers, but not true. They walk you through the process step by step, helping you add visuals, sound and transitions until you have a completed project. You will have at your fingertips more tools than you can ever use to help you assemble your final underwater video presentation.

YOU WILL HAVE AT YOUR FINGERTIPS MORE TOOLS THAN YOU CAN EVER USE.

Importing Visuals

To begin making digital slide shows, your underwater prints, slides and color negatives need to be scanned into the computer. These digital still images can be edited in a photo editing program such as Adobe Photoshop. Since digital video production uses a 720 x 480 format, it is a good idea to crop and resize the still images so they fit into that format. Try to keep the file size no larger than 1440 x 960 and in an uncompressed format such as TIFF. This uncom-

pressed format allows the digital slide show programs to process the images faster.

Digital slide shows are not limited to still images. They can also incorporate moving images transferred from your video cameras. If your video camera is analog, you must import the data via the video input jacks on your graphic's adapter card. Since digital video is already converted, it can be directly imported into the digital slide show program via the USB or Firewire port.

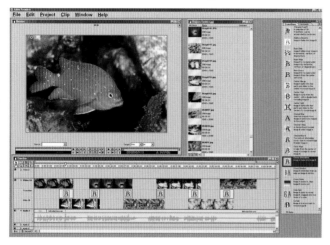

The digital slide show edit screen includes a library of images, soundtrack, transitional effects, multiple tracks for mixing images and a special effects library.

With each of these software programs, when you open a new project, a visual timeline is created. You then drag and drop elements along this timeline. Your images are stored in a media library so you can access them as needed. A thumbnail of each image, the transition between each image and the accompanying sound files are displayed on a track.

Soundtracks

Sound can be input through audio input jacks in the computer and converted to digital sound files. If the

This animation effect was created in a 3-D modeling program called Bryce. Each frame of video can take from one to ten minutes to render.

Editing visible audio tracks makes creating soundtracks a dream.

soundtrack needs editing, you can use one of many sound editing programs that are included with your sound card or any digital slide show program.

The soundtracks in the more professional programs allow you to cut, splice and alter the way you hear the soundtrack. You can add multiple tracks of music and mix it with narration. Any part of the soundtrack can be faded, dissolved, sped up, or slowed down and it appears visually on the screen.

Transitions

Transitions are visual changes between scenes or from one video clip to the next. We used to call them dissolves when we used slide projectors, but now with video you can create hundreds of effects. A special transitional effects library is available with hundreds of effects that allow one image to trans-

form into another. You can zoom one image out and zoom in the next. One image can turn into a paper airplane and fly away disclosing the image underneath. Most anything you can imagine is possible.

To see how they work, select a couple of underwater images and drop them on your timeline. The first image would be on track 1A and the second on track 1B. Overlap the images a little and drop a transition effect on the transition line. The more you overlap the images, the longer the transition.

The digital dissolve is a slow blending of one image with another over a short period of time.

Titles

Titles can be single frame images or animated text files that rotate, fly and zoom onto your screen. The stills can be generated in photo editing programs like Adobe Photoshop while you will need 3-D programs to generate the animated text files. With the animated text programs, you type in the text and give it a path or special effect to perform in an allotted amount of time.

Preview

The best part of all these programs is that, at any time during the creation process, you can stop and preview the portion you have completed on a small video viewer. If an image comes in a little late or doesn't match the soundtrack, simply drag it a little

to the left or right and preview the file again. You can lengthen the transition or add a photo or two. Keep tweaking it until you achieve satisfaction, save the file and you are ready to move onto the final process.

Special video effects such as fish bites out of one scene to the next are easy to create with a digital slide show.

Output

The most inexpensive way to output your file is with a video graphic card with its own video output jack. These cards are normally used to drive the computer display in your system, but can also output your video production to television or VCR. When you have previewed your final file and want to call it a wrap, just pop in a blank video tape and record as many copies as you need.

If you want a more professional output, you may want to consider a video board specifically designed for input and output of video signal. Pinnacle

A nudibranch changing to a starfish via a looking glass is just one of the many effects available for digital slide show production.

Systems has expanded their line to include video boards for all levels of digital photography from beginner to advanced professional. Most of these boards can output broadcast video at 720 x 480 pixels for up to thirty frames per second.

○ Good and Bad Points

The flexibility of this digital slide show system is incredible. No more dust on your images as they are projected on the screen. Image registration is no longer a problem. The failure rate of video is less than with slide projectors. Jammed cardboard mounts are a thing of the past. Special effect zooming titles are no longer jerky since you don't have to wait for the projectors to cycle. Now it is easy to

make image changes, update sections of the show, modify the soundtrack and quickly output it all to video tape.

This brings us to the down side of this new technology—image quality. There is no way around it. A slide projected on a projection screen is much higher quality than a video image. With traditional slide shows we presented full screen 35mm slides. By Kodak's research it would take at least a digital resolution of 3072 x 2048 pixels to match 35mm film. If you remember, video is only 720 x 480 pixels. Quite a bit of difference, huh?

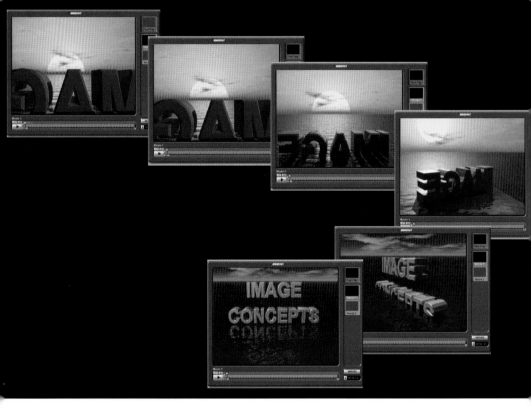

DVD authoring software takes your video presentation and transfers it to DVD with menus, special effects and titles.

This lower resolution is tough to swallow, but it all comes down to perception of quality. People today are used to watching television and video with this lower resolution. Often the image resolution isn't as important as the content of the production.

Another problem is that to maintain broadcast video quality, these output devices need to continuously output thirty 1+ megabyte files per second. Even with compressed files, the system requires a constant video stream that can process and output at least 3MB per second. Most hard disks can do that in a burst, but not for ten to fifteen minutes at a time. The solution is a device called a RAID (Redundant Array of Independent Drives). This requires a special board and two to four identical hard drives that act as one drive. It can deliver more than 25MB per second for as long as there is disk space.

THIS REQUIRES A SPECIAL BOARD AND TWO TO FOUR IDENTICAL HARD DRIVES.

Image
Compression

IT SEEMS LIKE WE NEVER GET ENOUGH time or hard disk space. Not having enough time seems to be the disease of the twenty-first century. Not many people feel they have adequate time to accomplish all they wanted in a single day. Regarding hard disk

IT SEEMS LIKE WE NEVER GET ENOUGH TIME OR HARD DISK SPACE.

space, it used to be that if you said you had a giga-byte hard drive, you immediately got "Oohs" and "Aahs" from those around you. Now if you say you have a gig drive, they only reply "How *many* gig?"

○ Image Compression Types

You're going to find that, over time, you will start to collect many scanned and edited underwater

images. Most of these converted digital files will be at high resolution and with file sizes of 18+ megabytes, they add up quickly. Even with gigabytes of hard disk space, you will probably need to use a file compression to reduce the file size for long term storage.

JPEG

The solution to this problem is the compression format called Joint Photographic Experts Group, or JPEG (pronounced "jay-peg"). It comes as part of most editing software programs and is also the compression format for many digital cameras. It uses special mathematical algorithms to compute color trends at the pixel level and group these color similarities into a compressed format. Scanned photographic images consist of rows of red, green and blue pixels. These files are like the scan lines you see on your TV set. By compressing or removing similar data, the file becomes smaller, yet it still maintains the visible quality of the original.

BY COMPRESSING OR REMOVING DATA, THE FILE BECOMES SMALLER.

For example, let's say that the in the top of an underwater image, the water changes from light blue to dark blue. The JPEG algorithms would look at this section and apply a formula that would provide the same tonal gradation, but requiring less data. If the original image had blue values of 190, 191, 193, 195, 194, 196, 198 and 200, the JPEG file would indicate a color curve starting at 190 and ending at 200. The

results would be smoother than the original file and take up less storage space.

The most obvious advantage of JPEG is increased storage space. Photo files can get very large— even with CD writers and gigabyte drives, one editing session can easily fill your storage devices. When your project is completed, use a batch process program to batch compress all the files to JPEG. Once their integrity has been verified, you can delete all the uncompressed versions. The JPEG can then be written to tape, CD or other archival storage device.

THE MOST OBVIOUS ADVANTAGE OF JPEG IS INCREASED STORAGE SPACE.

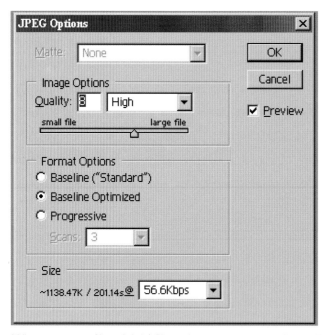

When you save a file in Adobe Photoshop as a compressed JPEG file, information about approximate file size and transmission time over the Internet are displayed. If the file is too big, move the slider down until the size is right for your application.

When JPEG was first introduced, computer experts were thrilled. They could get more samples onto their software diskettes and could make their tutorial programs larger. Photographers weren't as happy because the thought of throwing away data just to save space was unacceptable. Photographers trying JPEG for the first time didn't understand exactly how it worked, so they often misused it, resulting in poor quality images.

When you get ready to save a file in the JPEG format, you will be asked which level of quality you desire. As you increase the effect of removing and compressing data, the file becomes progressively smaller. The trick is to find a compression level that provides satisfactory image quality with a corresponding file size to meet your needs. To maintain high image quality on an 18MB file, we find that a level nine or higher provides acceptable results. If you were going to send the same file over the Internet, it would be too large, even compressed. You would need to resize it down to approximately 800 x 800 and save it again at level four, yielding a file that is less than 100K.

YOU WILL BE ASKED WHICH LEVEL OF QUALITY YOU DESIRE.

Fractal

Fractal compression is a new and upcoming compression format that offers great promise in the world of digital imaging. Patented by Michael Barnsley, founder of Iterated Systems, this compres-

sion scheme contains a record of repeated patterns that exist in the image rather than a set of values for every pixel. When the file is saved, the pixel data is replaced by Fractal mathematics, so the pattern information is compressed into a very small file.

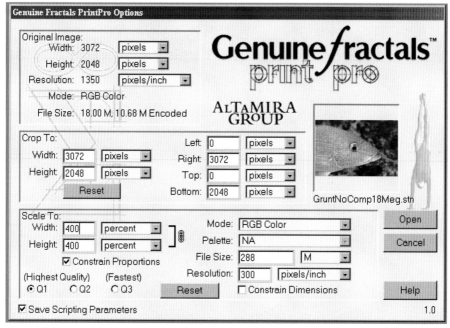

Fractal compression software allows you to create images much larger than you started with. Compress the film in the Fractal format, then reopen it at any size you want—upwards toward 1G if you want. You can make billboard-size images with a standard 35mm image.

Since the Fractal Image Format (FIX) file does not record specific pixels, the file can be expanded to any size without any interpolation. When you expand the file, it will ask you what resolution you would like. Each pattern is then proportionally expanded to create a bitmap in the requested size. You should start with at least an 18MB file in order to expand to 400–500MB.

LEFT: The original 8MB image was compressed to less than 500k with Fractal compression software. Extreme enlargement of eye to see effect of compression.

RIGHT: Original 8MB image compressed to less than 900k with JPEG compression software. Extreme enlargement of eye to show effect of compression

Wavelet

Wavelet compression is a high tech process that is used by some pretty impressive companies such as the Nomad Rover for NASA, the missile guidance systems for Hughes Aircraft, Fuji Film and Corel. The technology behind Wavelet is complex and requires advanced knowledge in math and physics for it to make sense. We deciphered that Wavelet com-

THIS COMPRESSION IS USUALLY FASTER THAN JPEG OR FRACTAL.

pression uses averages and differences of adjoining pixels at discrete levels. When the difference is close to zero, that data is thrown away and only the averaged data is saved. This compression is usually faster than JPEG or Fractal and can embed image enhancements such as sharpening, contrast control, magnification and edge enhancement.

○ Final Thoughts

The Internet has changed our lives. Not long ago if you wanted to send a treasured photo to a distant love one, you relied upon the speed of the post office. Now, you can take a picture and transmit it instantly over the phone lines via the Internet. Family and friends are now able to see pictures

YOU CAN NOW VIEW GREAT LOOKING PHOTOS IN WEB PAGES.

from your dive vacation shortly after you arrive home. Thanks to image compression technology, you can now view great looking photos in Web pages, via e-mail and in digital photo albums.

Archival Data Storage

NOTHING IS MORE FRUSTRATING than spending time scanning, editing and saving some fantastic underwater images, only to find your hard disk failed. Safe data storage has always been a concern for the digital photographer. Images scanned into the system can be re-scanned and edited again, but your lost time is usually more valuable than the lost hard disk. We've had our share of image losses and that has made us paranoid about proper data storage.

DATA STORAGE HAS ALWAYS BEEN A CONCERN FOR DIGITAL PHOTOGRAPHERS.

We have tested a variety hardware devices that store data and think we finally have a two-step solution. It's not going to be cheap, but if you add up all

the money you have spent on dive trips, underwater camera systems, film and processing, a little bit more is not going to hurt. The formula to insure the safety of your digital files is quite simple—a backup hard disk system for temporary storage and a CD system for archival storage.

○ Temporary Backup Storage

A RAID (Redundant Array of Independent Drives) device is a group of two or more identical drives clustered together to make one hard drive. This provides large, fast data storage on a single drive that doesn't cost an arm and a leg.

When RAID drives first came out, they were configured with SCSI drives because they offered larger capacity and were faster than IDE drives. The problem was the exorbitant costs involved in buying two

Load Balancing

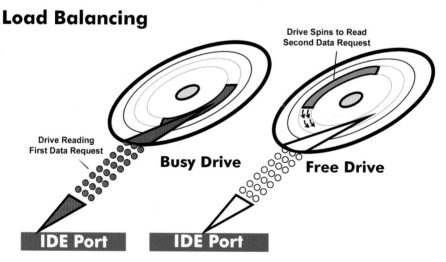

RAID drives are clusters of drives acting as one drive. They can balance the speed at which data is recovered and written to the clustered drives. Because of the high speed of these drives, they are great for CD burning and image editing. (Illustration courtesy of Promise Technology, Inc.)

to eight drives. Recently however, the lesser expensive IDE drives have increased their capacity to more than 30G per drive and can read data as fast as 66MB per second. If you cluster four drives together with a RAID board, the speed increases two to three times as the data is spread over all four drives. This method of setting up a RAID is called "striping" and is best suited for speed.

We know you're going to say that if one of those drives fails, you stand to lose data. This is very true,

The average size of a RAID (Redundant Array of Independent Drives) is four. You can combine all four drives as one large drive, or split (mirror) two sets of two drives so that you have automatic backups of all your data.

and the more paranoid digital editors use a RAID setup called "mirroring." With this system you have four drives on a board and the data is split equally between two sets of two drives. Every time you save a file, it is saved twice, providing instantaneous back-up. If any one of the four drives fail, the firmware program on the RAID board asks if you want to replace the drive or rebuild the one that crashed. The program will then fill in all the missing data from the good drives and you are back in business.

○ Archival Storage

Now that you've finished editing your images, your hard disk is starting to get full. It's time to move the files to a permanent loca-tion and the best choice is a CD. They are very reli-able, cost less than a dol-lar and last a long time. The CD has been around for more than ten years and has become the industry standard.

IT'S TIME TO MOVE THE FILES TO A PERMANENT LOCATION.

Computer data is made up of bits of data repre-sented by 0s and 1s called the binary system. When you burn data onto a CD, a very tiny laser beam fires at extremely high speed down at the wafer thin metal surface. Holes are burned into the surface in special combinations that can be read back as 0s and 1s. On a single CD, 650 million bytes of data can be burned into its surface. The etched holes are so small that the only way you can see them is with an elec-tron microscope.

Portable CD burners are great for storing digital images on dive trips. Images are transferred from digital cameras to the computer and then burned onto CDs.

When CD recorders first came out they were very complicated and cost thousands of dollars. Today they are easy to use, produce high quality and can be purchased for less than $200. Most CD burners come with easy-to-use software designed to load files and burn them onto your CD. If you can copy files from your hard disk to a floppy, then you can burn CDs. When writing a CD for the first time, or if you have encountered problems, use the test function. Otherwise, you don't really need it. To guarantee that it has written correctly, you should try to load a couple of the files from the recorded CD.

IF YOU CAN COPY FILES FROM YOUR HARD DISK TO A FLOPPY, YOU CAN BURN CDS.

CD-R and CD-RW

When you go shopping for a CD burner, you will probably see the two terms CD-R and CD-RW. The CD-

RW is like a hard disk because you can read and write data thousands of times to the same disk. The drawback is that the drive and the blanks are more expensive and the risk of losing data is the same as with a hard disk. A CD-R can have data written to it only once and cannot be erased. The data is chiseled in metal, and if you store your CDs properly, you can feel confident that your data is safe.

CD-R drives can be IDE, SCSI, USB or Firewire. We see little difference between their operation, so the choice is yours. Most CD-R units are at least 4X write and 12X read. If your computer has the space and the drive connector, we recommend a second CD-ROM drive as a reader. Writers don't read as well as readers. Most CD-ROMs cost about $75 and will cut down on the wear and tear on your writer.

If you have set up your computer properly, you should have at least one separate program drive and

The biggest problem with CD burners is getting a hard disk fast enough to transfer the constant data stream that CD burners require. Most burners have variable speed and programs that determine the maximum speed of your system.

a very fast data drive. The reason for the second data drive is that temporary data is constantly written, deleted and rewritten. There is always the chance that this continual data writing will eventually cross into the programs. The second reason for the fast data drive is so you can quickly transfer data to the CD burner. Most CD burners require a constant flow of data at a specific speed without interruption, so many CD burners often have extra internal RAM to compensate for data stream lag. You should purge your data drive periodically, so that it does not become fragmented which could also slow the data transfer process.

Most of the newer CD writer programs have a labeling function that uses the date as the CD identification number. For example, CD number 990518-1415 was burned on May 18, 1999 at 2:15PM. Whenever you access the CD, this number will appear as its title. This makes it especially nice because it automatically organizes your CDs in chronological order when you file them away on the shelf.

MOST OF THE NEWER CD WRITER PROGRAMS HAVE A LABELING FUNCTION.

Multi-Session Recording

In every computer process there is a weak link. With CD burners it comes under the heading of multi-session. When you write a session on a CD, the burner writes all the files and then makes a table of contents to tell the CD reader the file location. When you write a second or third session, the burner picks

up the table of contents, adds new files and writes a new table of contents at the end of that session. If for any reason the session you are writing crashes, the data in all previous sessions will be lost.

If you must write a second session to a CD, don't worry about losing the data from the first session. Simply copy it to a backup directory on your hard disk. When the second session is written and verified, simply delete the backup directory.

○ Final Thoughts

We rarely write multi-sessions and find the single session the most reliable method for archiving data files. Blank CDs now cost less than a dollar each and store 650MB of data. At that price, you don't

BLANK CDS NOW COST LESS THAN A DOLLAR EACH AND STORE 650MB OF DATA.

have to fill them completely. Most hard disks today hold gigabytes of data, so wait unit you have almost 650MB of data and then write it to the CD.

The best way to get started and feel comfortable with CD burners, is to buy a half dozen blanks and practice. Write a full session of 650MB, then write several multi-sessions. Copy some small files and then try several larger ones. When you feel comfortable burning CDs, give the real thing a try. It's the easiest way we've found to archive data files.

Photo Database

Finally, we are at the end of the digital process. We have taken our underwater images, scanned them, edited them, saved and archived the images. Now, how are we going to find a specific image months later? Is it possible that we will remember the specific file name and which CD it is on? Probably not. We're going to need a photo database to help us quickly find our images. There are so many database programs, which one do we choose?

HOW ARE WE GOING TO FIND A SPECIFIC IMAGE MONTHS LATER?

○ Drafahl Numbering System

When we first started in photography, our filing system was far from perfect. We used index cards, log-

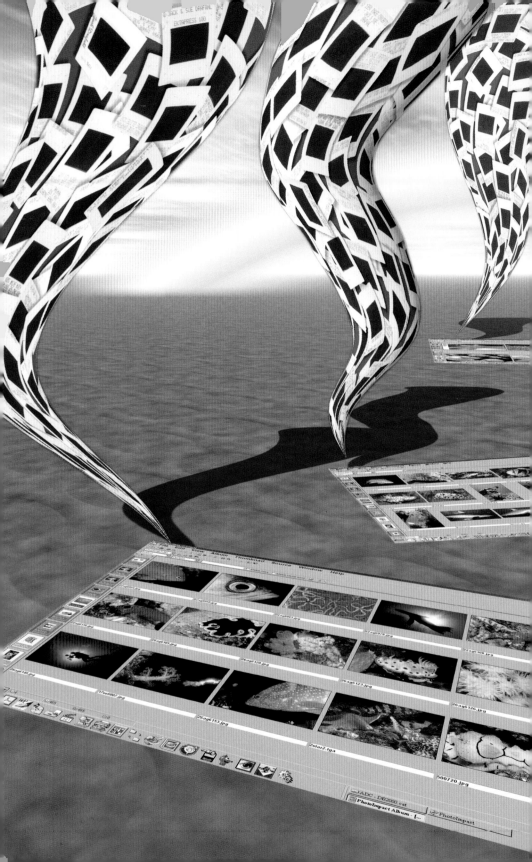

books—and if we waved a wet finger in the air long enough, we usually found what we were looking for. When computers became popular, everyone convinced us that our filing system was antiquated and we should reenter all the data into a database. Being the open-minded folks that we are, we gave it try. We found that most programs were slower than our mechanical methods. The data input was labor intensive and when we needed a photo, all we ended up with was an image name and number on a list. If we wanted to see the picture, we still had to go to the files and retrieve the image.

MOST PROGRAMS WERE SLOWER THAN OUR MECHANICAL METHODS.

So, we decided to sit down and develop our own system for filing our underwater negatives and slides. Our Drafahl numbering system allowed us to identify a specific subject and the number of images filed under that subject heading. Now that we had a system, we set forth to individually number our vast collection of images. Then reality hit. There was no way the two of us could catalog all our images before it was time for us to retire. It left no time for diving—and that was unacceptable!

So, then came plan "B." We would only number images as they were sent out for potential stock photo sales or to accompany a magazine article. No, all of our images wouldn't be numbered in our lifetime, but the valuable ones would be labeled. We would now have some semblance of order and still have time to go diving.

○ Photo Database Programs

In time, computer programs have become more sophisticated and photo database programs are plentiful. Inexpensive scanners now make it possible for traditional slides and negatives to enter the digital world. As digital photography has entered

VERSATILITY IS GREAT, BUT HOW DO WE KEEP TRACK OF ALL THESE IMAGES?

the arena, photographers are starting to use digital cameras to record those special moments in time. This versatility is great, but how do we keep track of all these images?

We have prepared a list of database software manufacturers included in the Appendix. Almost any of these database programs will work, just make sure they have the features you require. Features to consider are: thumbnail size, catalog capability, a good search engine, ability to print thumbnails, additional data fields and the ability to link to your favorite editing program. The key to making any of these database programs work is taking the time to enter the data.

The secret to success using a digital database is knowing how to use the tools and keeping the database updated. For photographers who have vast quantities of images in slide and negative format, remember to take your time scanning. You didn't take all those great underwater images over night, so don't attempt to immediately convert your entire inventory. Catalog your best images to start and add

new ones a bit at a time. If you want your digital database to work, you have to dedicate time and manpower to finish the project. It won't do any good if your enthusiasm for developing a cataloging solution wears off.

Color Negatives

If you shoot both negatives and slides you potentially have another problem. Storage of color negatives is not easy since you can't give each image a number like you can with slide mounts. Our solution was to mount each negative in a slide mount and label it the same way we do slides. This protects the images, allows us to weed out any bad images, group images according to subject and batch scan them. The downside is that not every photo lab can make prints from color negatives in slide mounts. That shouldn't be too big a problem because once the images are scanned into your computer, you can make your own prints using an inkjet printer.

OUR SOLUTION WAS TO MOUNT EACH NEGATIVE IN A SLIDE MOUNT.

It can get complicated figuring out which film images have been scanned and which ones haven't, so we devised a simple system. Whenever we need a digital file from a traditional film image, we pull it from the file drawer, scan it into the computer and add it to the digital database. Before returning the negative or slide to the traditional file drawer, we mark two dots on the negative or slide mount to indicate that it is a proud member of the digital

database. We use two dots because a single dot might be mistaken as an artifact. In the future, when we pull an image from the filing cabinet, we can quickly see that it has already been scanned.

Digital Camera Images

Databases are critical to cataloging digital camera images because without them you are working blind. Quite often, digital cameras come with their own database program. When you download images from your digital camera to these specific databases, the shooting information is transferred along with the file. If you import these digital files into the database you are using with your traditional film images, a possibility exists that the additional data will be lost. To protect this data for future reference, make a copy of these files before importing them into your main database.

Both slides and negative can be cataloged into photo databases.

Thumbnail Images

Once you have your images logged, you can access them via a thumbnail in the photo database. Thumbnail images make finding any photo a breeze. You can even cross reference the digital scan using the same number as the original film image, which is now safely stored away in the file drawer.

If the primary purpose of your database is to build a catalog for locating images, you may want to scan your images at thumbnail resolution. If you require a higher resolution scan of a specific image for another purpose, then you can re-scan later. There are a couple scanners today that feature a bulk attachment. This allows you to scan, catalog and build your database quickly.

○ Storage

Digital images from your photo database can be stored on a variety of media, but we have found the most reliable and cost effective to be the write-once CD. We prefer this device to all others because there is no chance that the files can be deleted. If

DIGITAL IMAGES FROM YOUR DATABASE CAN BE STORED ON A VARIETY OF MEDIA.

you change the file in any way, just copy a new version to another CD. Best of all, each CD is automatically given the time and date it was written as its catalog number.

We need to give you one word of warning. Make sure that you back up your photo database often. Although we use write-once CDs, we store them in a

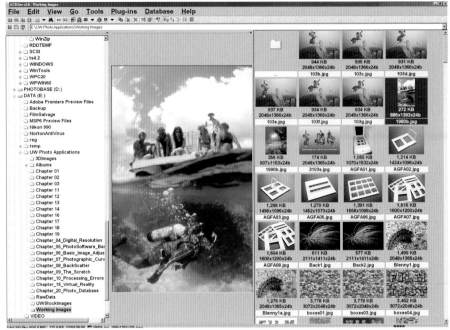

Most of the new photo database software is designed for digital cameras as well. In addition to the thumbnail, the program can extract additional information that the digital camera imbeds in its file. Most of these new programs look like file explorer programs that use thumbnails in addition to file names.

different location. It would surely be a heartache if all your work archiving your files was lost due to a fire or theft. If your software program has an auto-backup function, make sure that it saves onto a different drive than where you store your primary files. We set our system to backup every ten minutes, and—knock on wood—we have never yet lost a database file.

The Future of Underwater Photography

WE LOVE UNDERWATER PHOTOGRAPHY. When we started with traditional underwater camera equipment, we tried a bit of this and a bit of that to capture our moments underwater on film. Big strobes, little strobes, long arms, twin flashes, this film and that—we tried it all. We even designed new inventions in underwater photography in our attempt to make life underwater a bit easier. If any of our images were acceptable, we were thrilled.

WE EVEN DESIGNED NEW INVENTIONS IN UNDERWATER PHOTOGRAPHY.

There were no set rules of what you could or couldn't do to document the undersea world. The entire underwater world was fair game.

When we first started in underwater photography more than thirty years ago, the word "computer" was just a science-fiction term. Now we have embraced change and are slowly making the transition to digital. Thanks to the new digital era, we can now salvage and enhance underwater photos that were once destined for the trash can. The computer provides us the tools to combat the harsh underwater environment. We can scan in our underwater images and print photos to our inkjet anytime we desire.

WE HAVE EMBRACED CHANGE AND ARE SLOWLY MAKING THE TRANSITION TO DIGITAL.

Digital cameras are just getting established in topside photography. There are some rather impressive cameras that boast resolutions that rival film. They are still fairly expensive, but we see their quality improving and the prices dropping as digital cameras become more popular every day.

At this point in time, digital cameras are just getting their feet wet underwater. A few manufacturers have taken the plunge and introduced digital cameras and housings to prolific reefs around the world. They are the few, not the norm—yet.

We love film and film cameras and we have reviewed their latest, greatest achievements for over a quarter century. After extensive evaluations, we find we also love digital cameras. If we could afford it, we would go full digital underwater. In time, we will make the transition. The list on the facing page shows a few reasons why:

A D V A N T A G E S

- There is no film to buy.
- No film to process.
- No negatives to lose, scratch or fingerprint.
- Immediate feedback. No more wondering if you got the shot.
- Digital cameras record blue better than film.
- Wide exposure range holds shadow and highlight detail even in high-contrast shooting situations.
- No grain with digital cameras.
- Compact cameras.
- Most cameras offer different resolutions, so you have the option of storing more photos at the lower resolution.
- Some cameras even record sound or AVI movie files.
- With some cameras, you can hook up to TV screens to playback images when you don't have a computer handy.
- Most cameras have an effective ISO rating of 400, so they can respond well in low light situations. This allows you to use smaller flash units
- Photos are easily shown to friends and family worldwide via the Web.
- The best part is that this digital technology is being applied to point-and-shoot cameras, not just the high-end 35mm camera bodies.

If none of the points above convinces you, think of the environment. Photography is one of the largest polluters in the world. If we eventually eliminate film and processing, the only polluters left will be the manufacturers of the digital products, which is considerably less. If you want to do your bit to save

this planet, this is one excellent way to do it. You can show people what the undersea world looks like and reduce pollution simultaneously.

These are exciting times for underwater photographers. Film and traditional 35mm cameras are going to be around for a long time, but like it or not, digital cameras are here to stay. It's a whole

THESE ARE EXCITING TIMES FOR UNDERWATER PHOTOGRAPHERS.

new digital underwater world out there and we're all a part of it. Enough of all this digital jargon—let's go diving!

ABOUT THE AUTHORS

Jack and Sue Drafahl are a husband and wife team of professional undersea journalists, lecturers and multimedia producers. They have written over 500 articles for publications including *Sport Diver, Skin Diver, Diver, Petersen's Photographic, Rangefinder, Photo Lab Management, Ranger Rick* and the Cousteau Society. Jack and Sue are Platinum Pro 5000 divers, and Sue is an inaugural member of the Women Divers Hall of Fame. They enjoy teaching seminars worldwide on all aspects of photography, both topside and underwater. For more information, please visit them on-line at: jackandsuedrafahl.com.

Appendix

Because technology changes almost daily, the following list is only a starting point in your search for more information.

○ Software

ACDSee—www.acdsystems.com

Adobe Photoshop, Adobe Premiere—
www.adobe.com

Advanced Disk Catalog—www.
elcomsoft.com

Bryce, Corel Graphics Suite, KPT
Filters, Painter— www.corel.com

Cool 3D, Cool 360, MediaStudio,
MediaStudio Pro—www.ulead.com

Easy CD Creator, Toast—
www.adaptec.com

Eye Candy—www.alienskin.com

Hollywood Effects—www.pinnacle
sys.com

ImageAXS Pro—www.scansoft.com

Image Expert—www.sierra
imaging.com

Impression—www.minervasys.com

ixla Explorer—www.ixla.com

Media Browser—www.arcsoft.com

MGI PhotoSuite, VideoWave—
www.mgisoft.com

PhotoImpact Album, Photo Express
DVDit—www.dvdit.com

Picture It!, PowerPoint—
www.microsoft.com

○ Hardware

Applied Science Fiction, Inc.—
www.asf.com

ATI Technologies—www.ati.com

Fuji—www.fujifilm.com

Ikelite—www.ikelite.com

Kodak—www.kodak.com

Light & Motion Industries—
www.lmionline.com

Nikon—www.nikonusa.com

Olympus—www.olympus.com

Pinnacle Systems—www.pinnacle
sys.com

Promise Technology, Inc.—
www.promise.com

Sea & Sea Underwater
www.seaandsea.com

Index